– THE –

ROYAL BOTANIC GARDENS, KEW

Wonderful Flowers
COLOR
BY
NUMBERS

OVER 40 BEAUTIFUL IMAGES

SIRIUS

Royal Botanic Gardens Kew

The illustrations included in this book are all based on images taken from the Library, Art & Archives Collections of the Royal Botanic Gardens, Kew.

Special thanks to everyone at Kew Publishing for their invaluable help, particularly Pei Chu and Julia Buckley for sourcing and checking images.

SIRIUS

This edition published in 2021 by Sirius Publishing, a division of Arcturus Publishing Limited,
26/27 Bickels Yard, 151–153 Bermondsey Street,
London SE1 3HA

ISBN: 978-1-83857-604-2
CH006922NT
Supplier 29, Date 0121, Print run 11167

Printed in China

Created for children aged 10+

— THE —
ROYAL BOTANIC GARDENS, KEW

Wonderful Flowers
COLOR
BY
NUMBERS

Introduction

Painting flowers has been a popular pastime for hundreds of years and scientists, particularly botanists, have found accurate depictions of new and existing species of plants and flowers of invaluable help in documenting their findings and research.

The Royal Botanic Gardens, Kew Wonderful Flowers Color by Numbers book offers budding artists the opportunity to follow in the footsteps of some of the greatest botanical artists by recreating their work. Using the color key that can be found on the inside of the flap at the back of this book, you can build up a series of beautiful images and appreciate the diversity of our world's wonderful flora.

Among these pages, you will find black-and-white, numbered outlines of works by people such as the Belgian Pierre-Joseph Redouté, who was a court painter to the French queen, Marie Antoinette, and also worked for the wife of Napoleon Bonaparte, Empress Joséphine, as well as illustrations from a variety of periodicals. They include: *The Garden*, a 19th-century weekly periodical edited by William Robinson, *The Botanical Register*, which was begun by the botanical artist Sydenham Edwards, *Revue horticole*, a journal of practical horticulture published in Paris, and *Curtis's Botanical Magazine*, the longest-running botanical publication in the world, whose archives are held at the Royal Botanic Gardens, Kew.

These fascinating works of art will help you to appreciate the diversity of color in the plants. All you have to do is put together a set of colored pencils or pens and then choose an image to color. Enjoy!

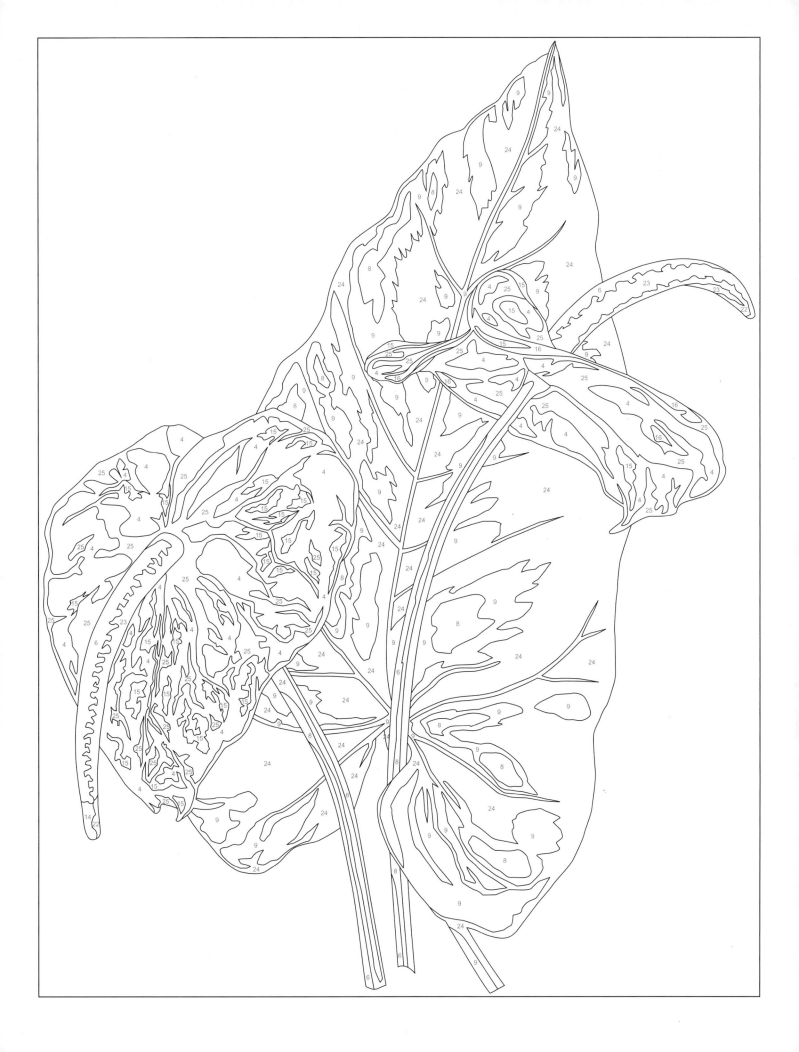

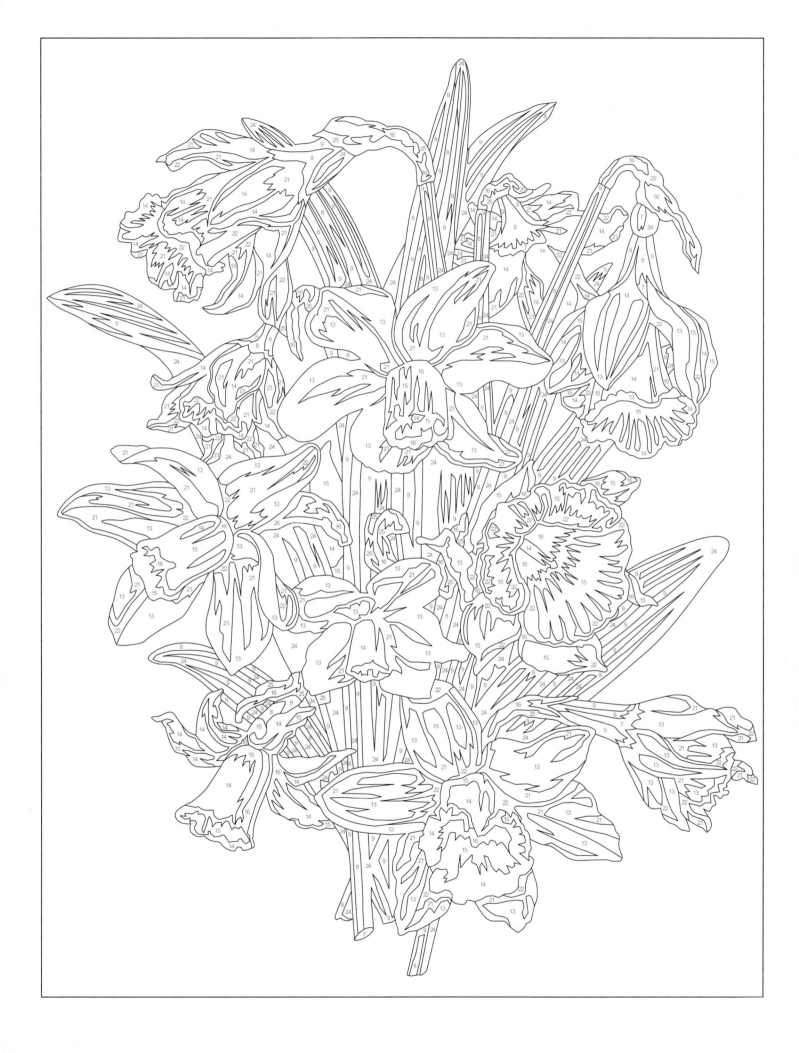

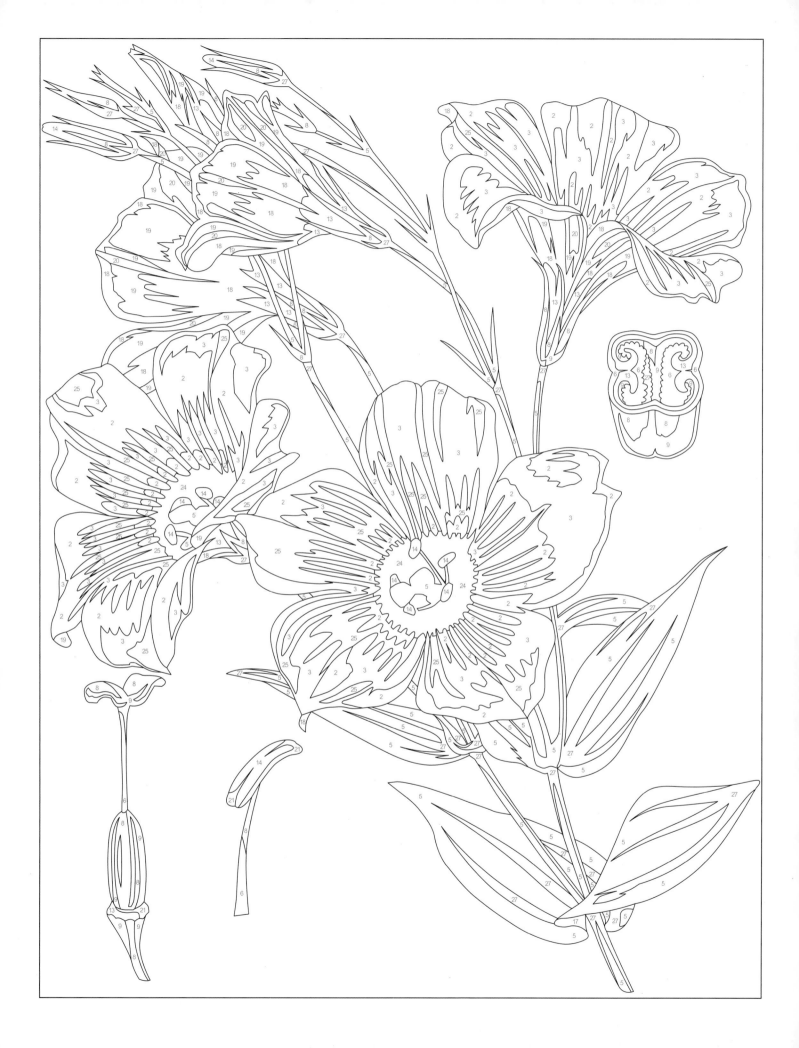

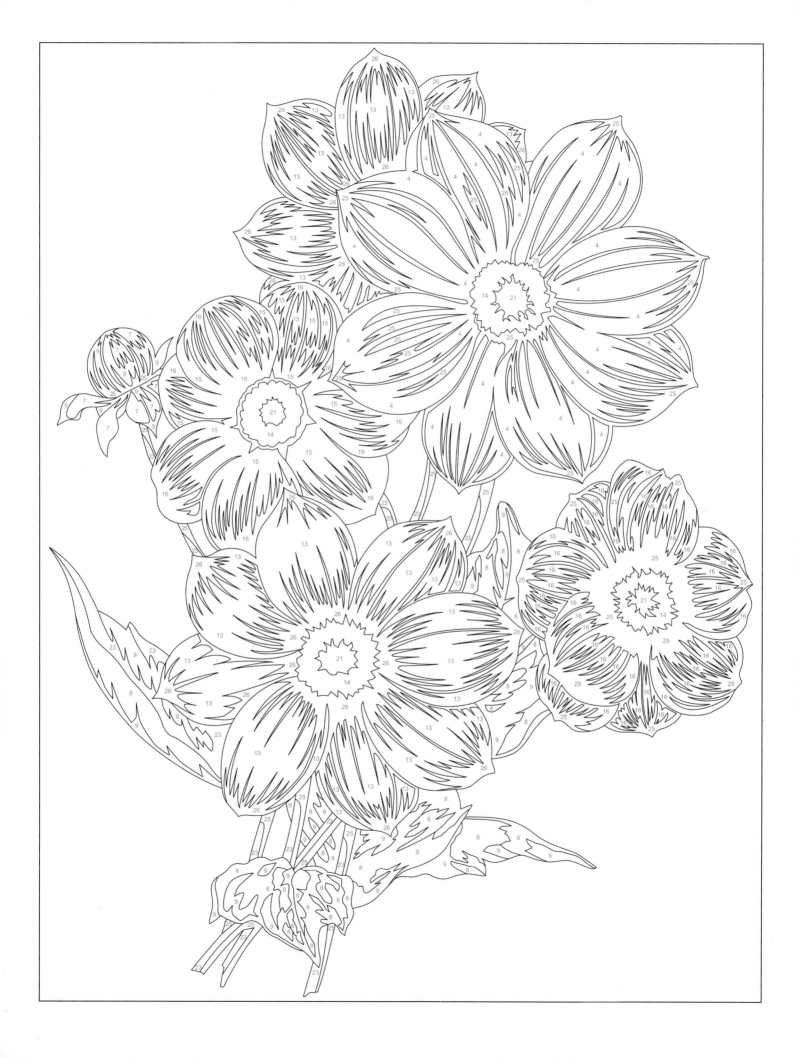

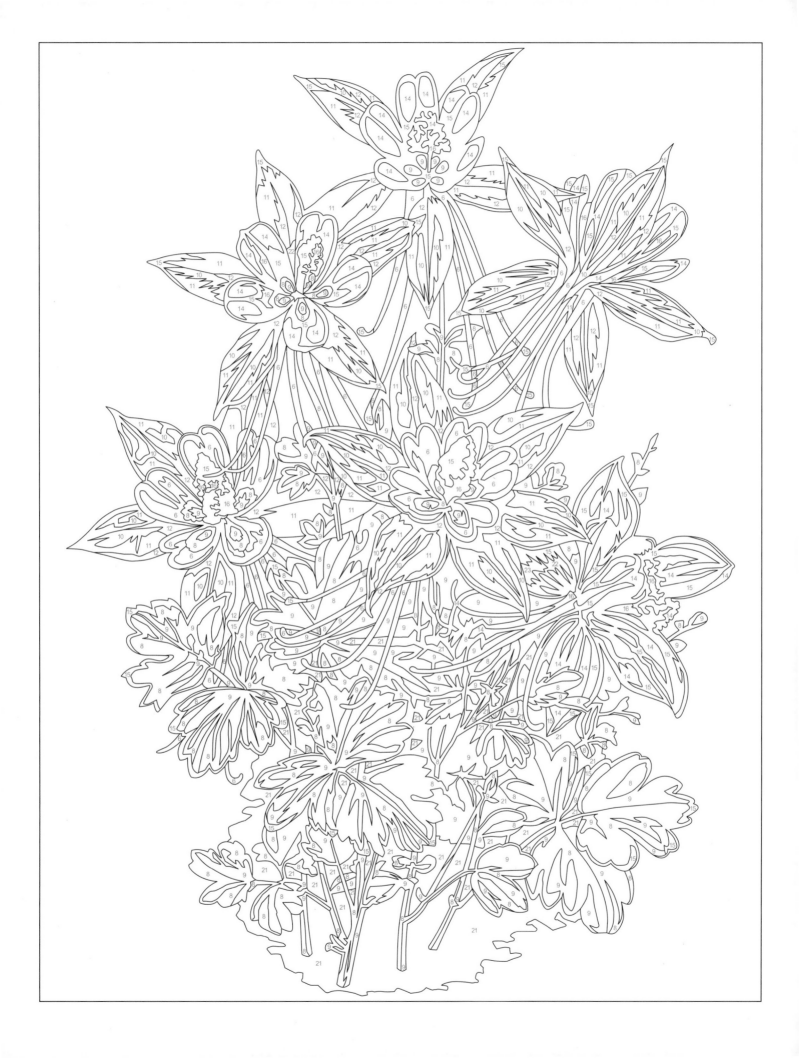

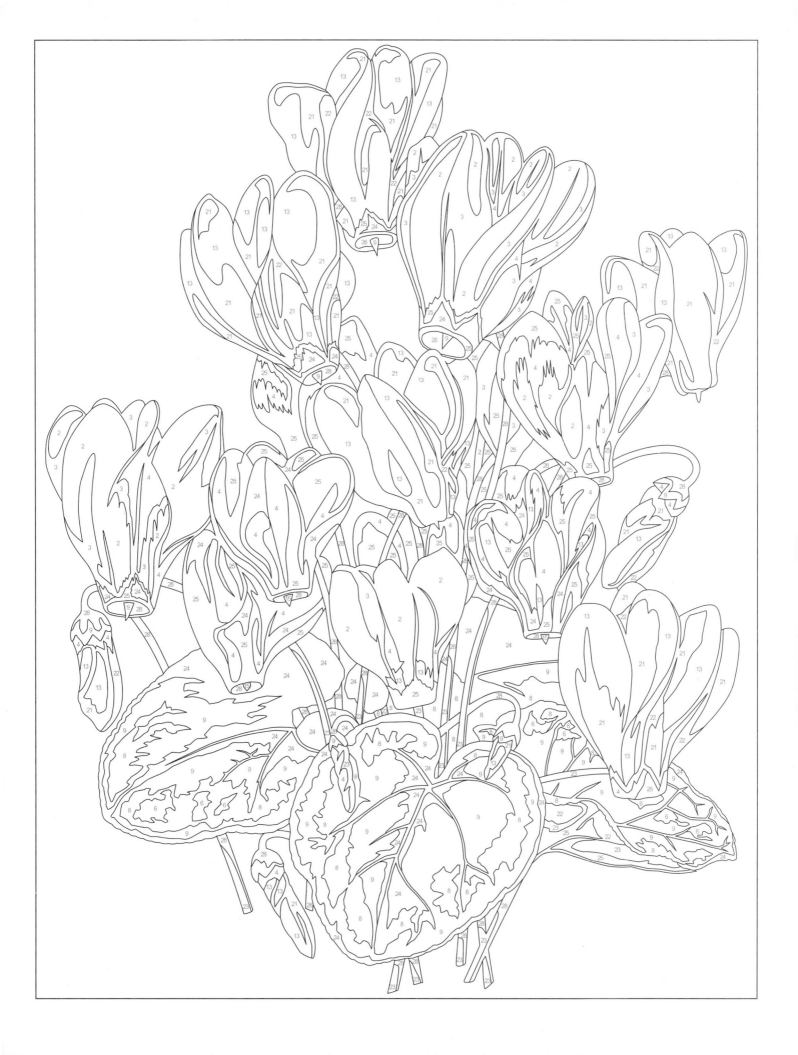

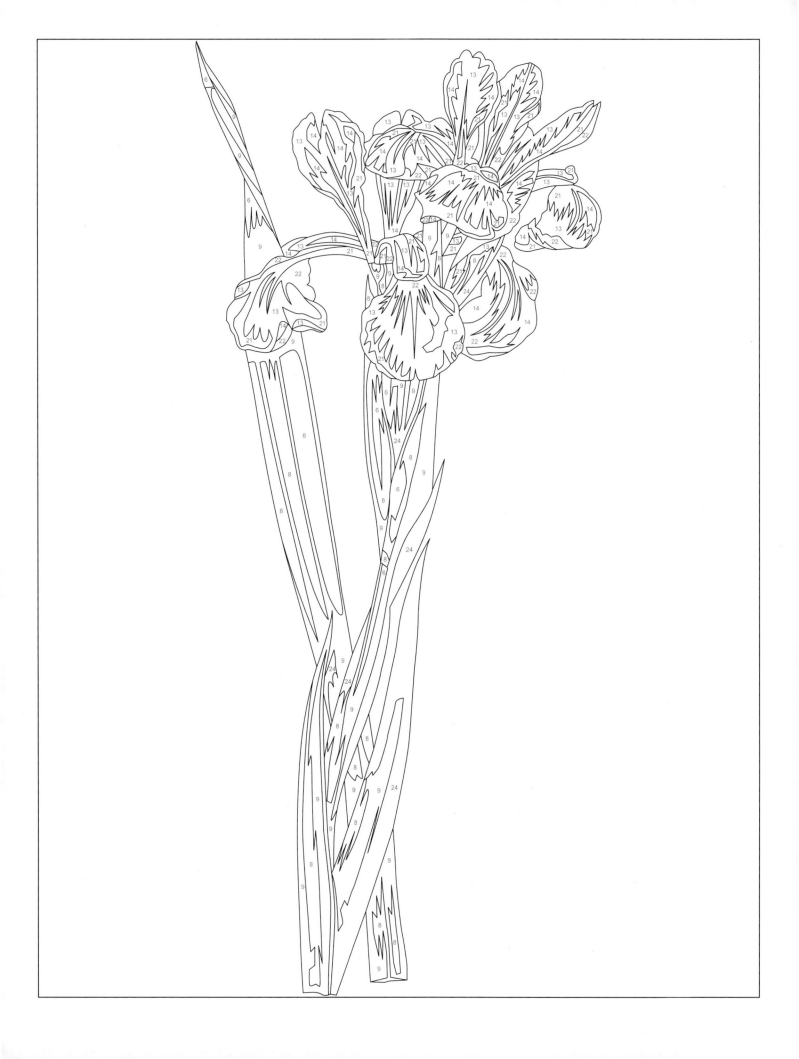

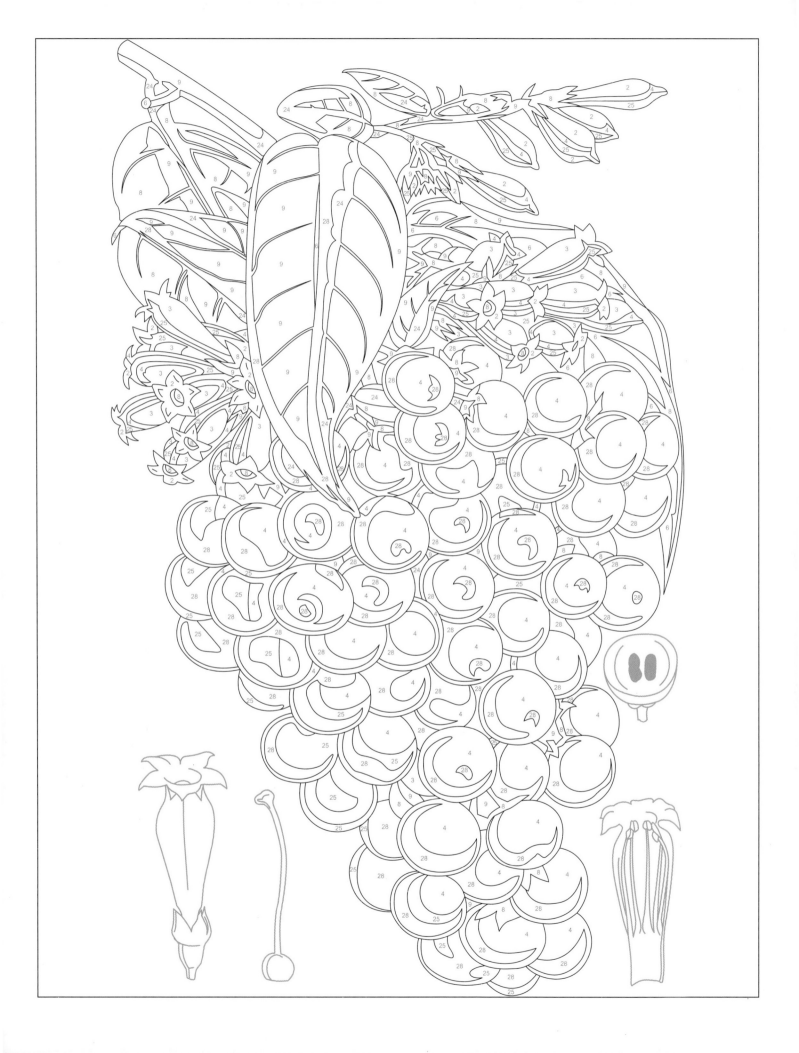

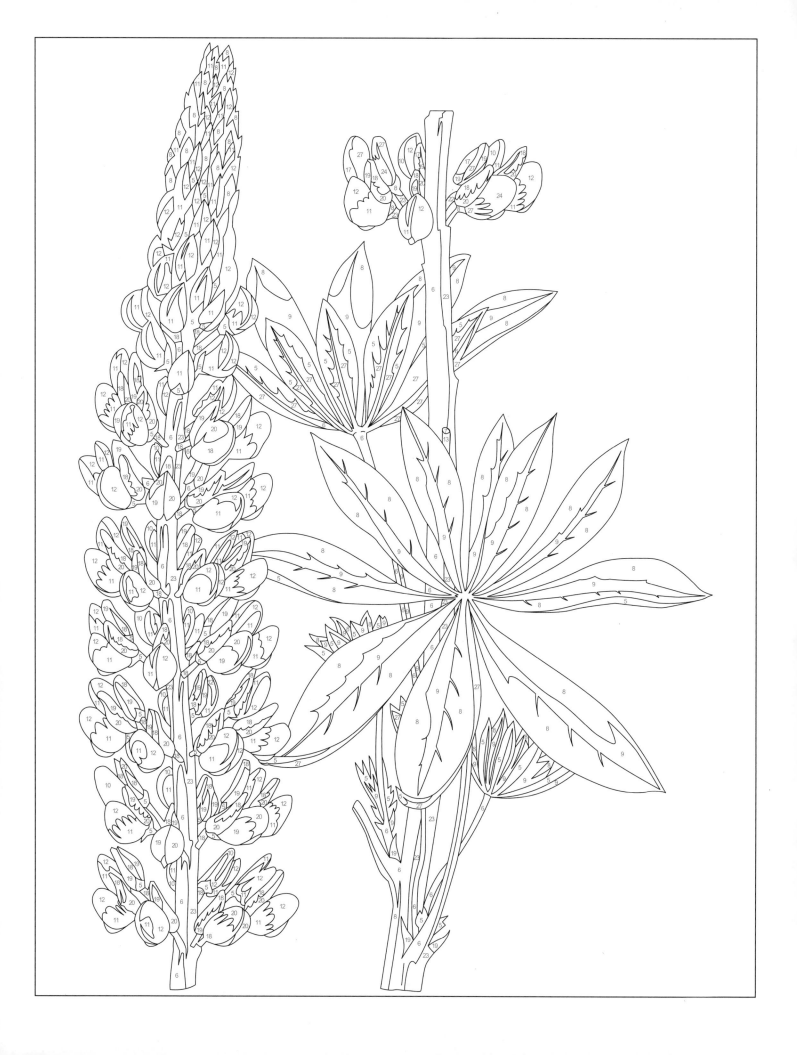

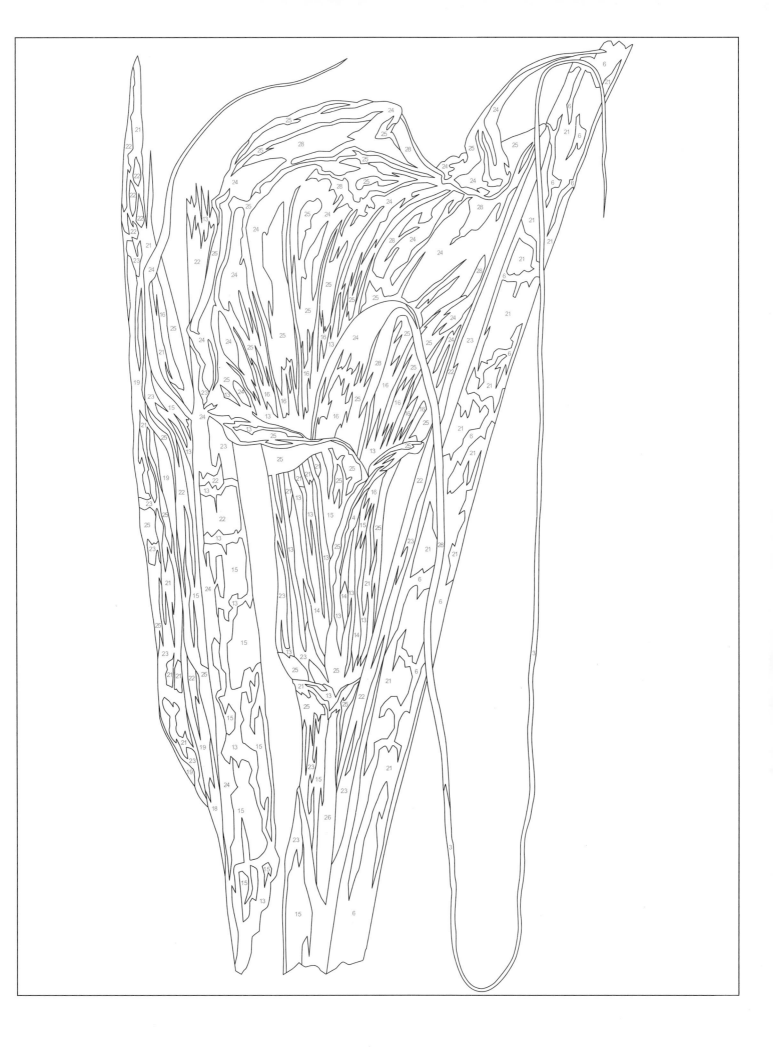

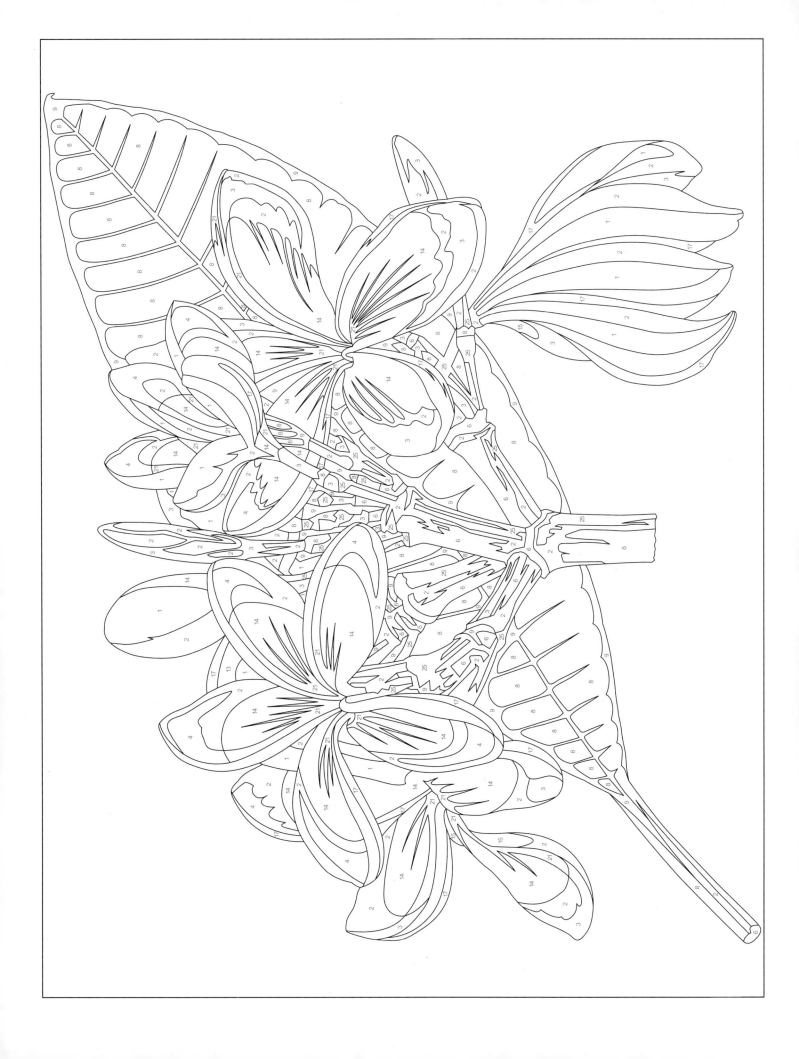

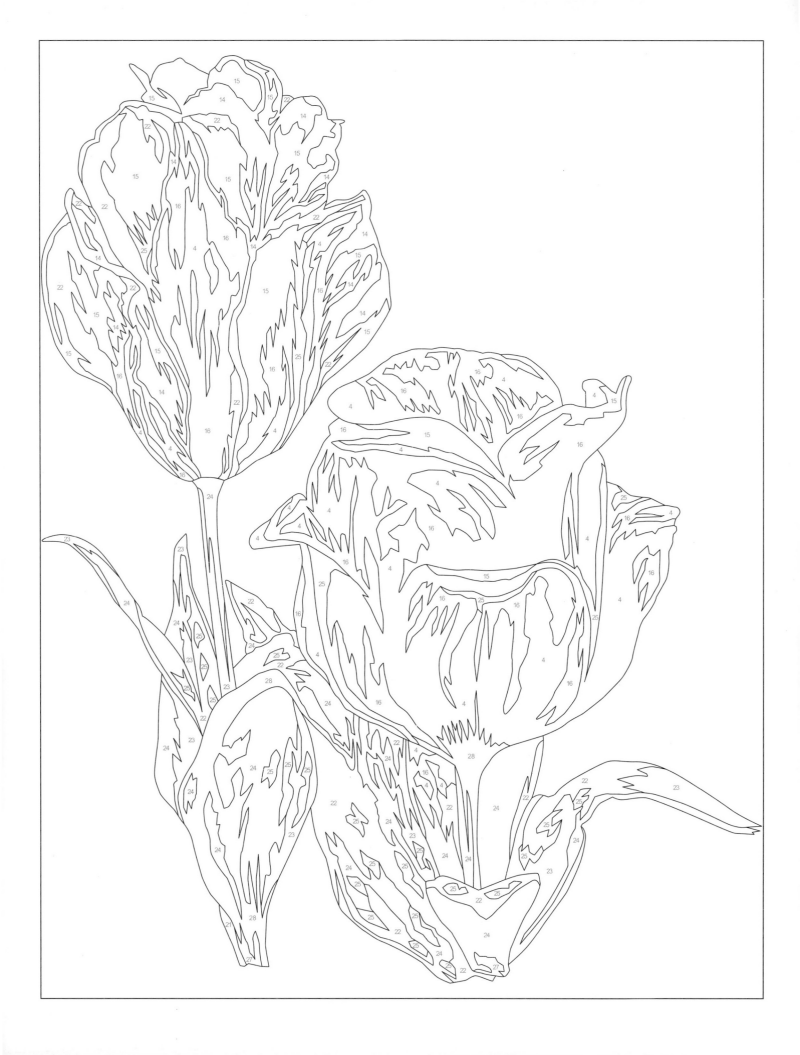

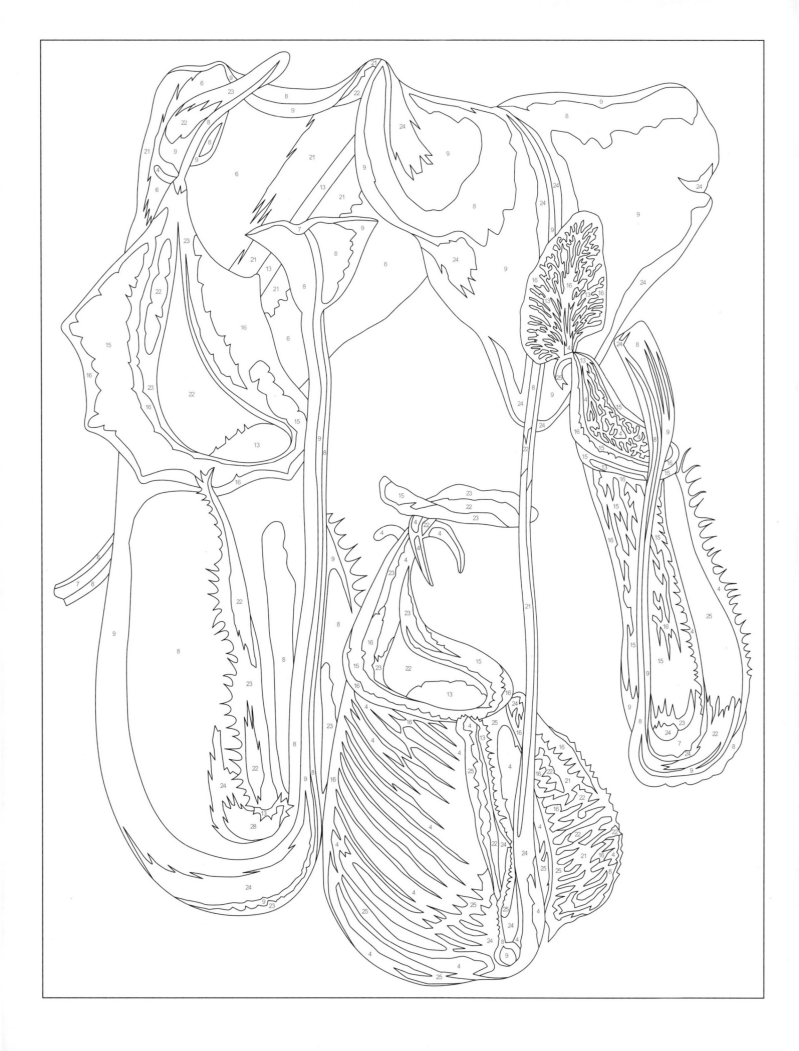

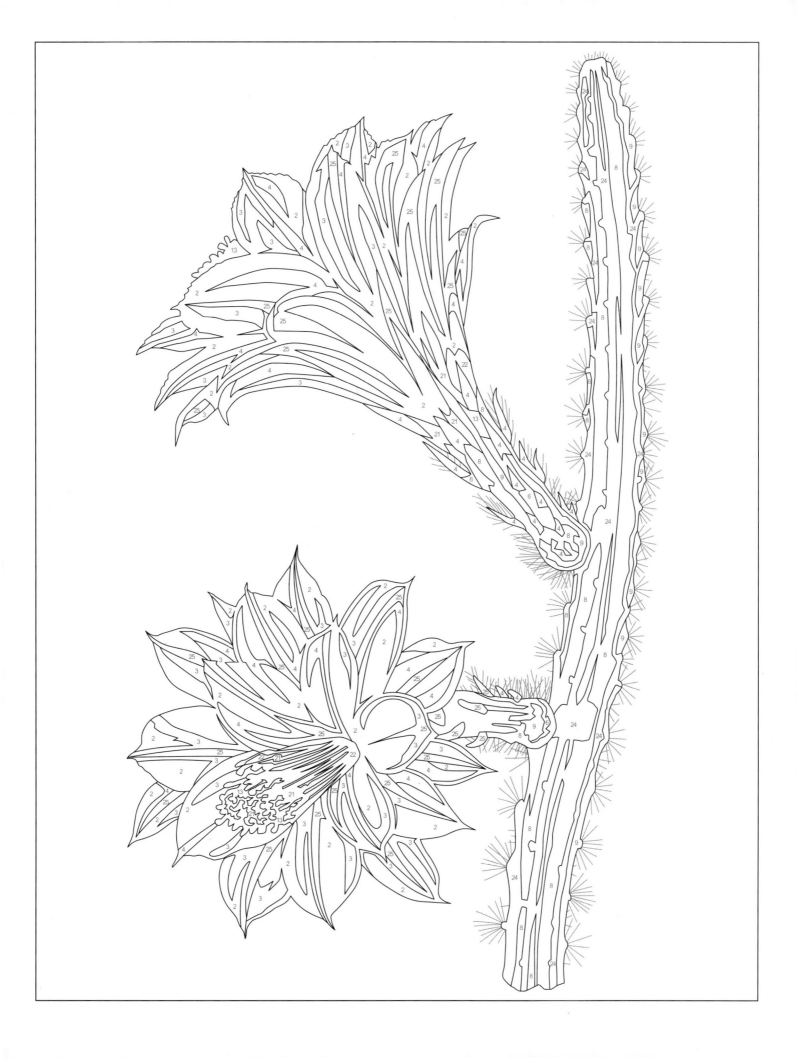

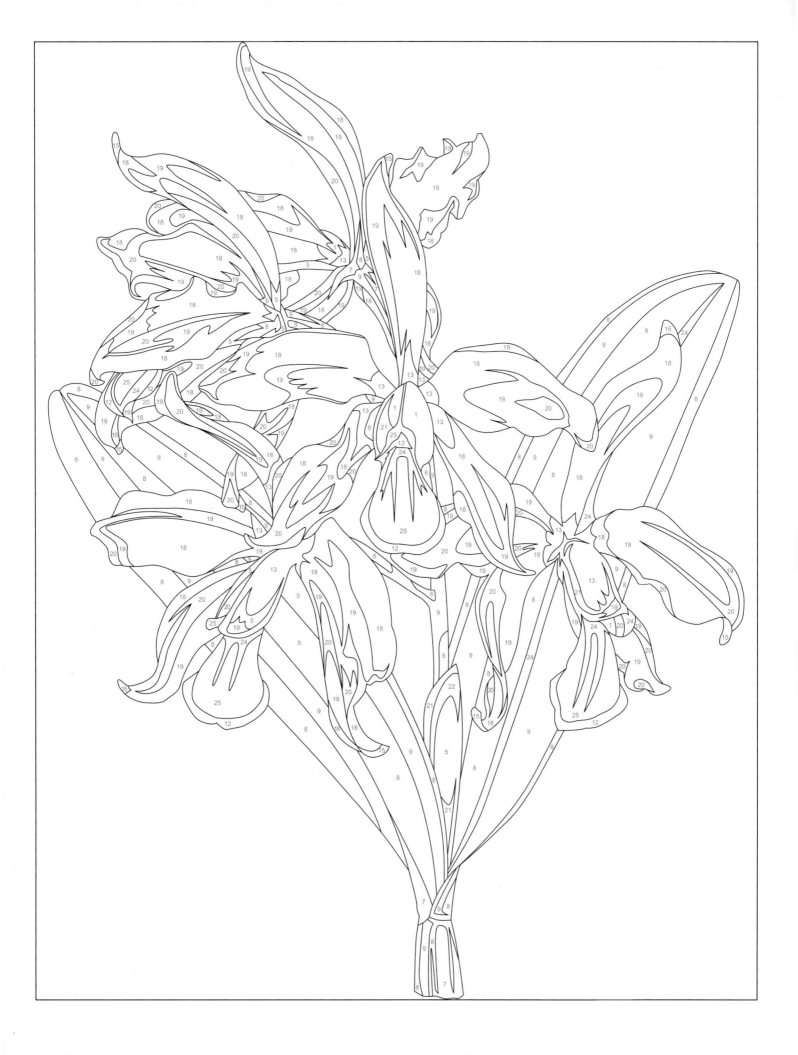

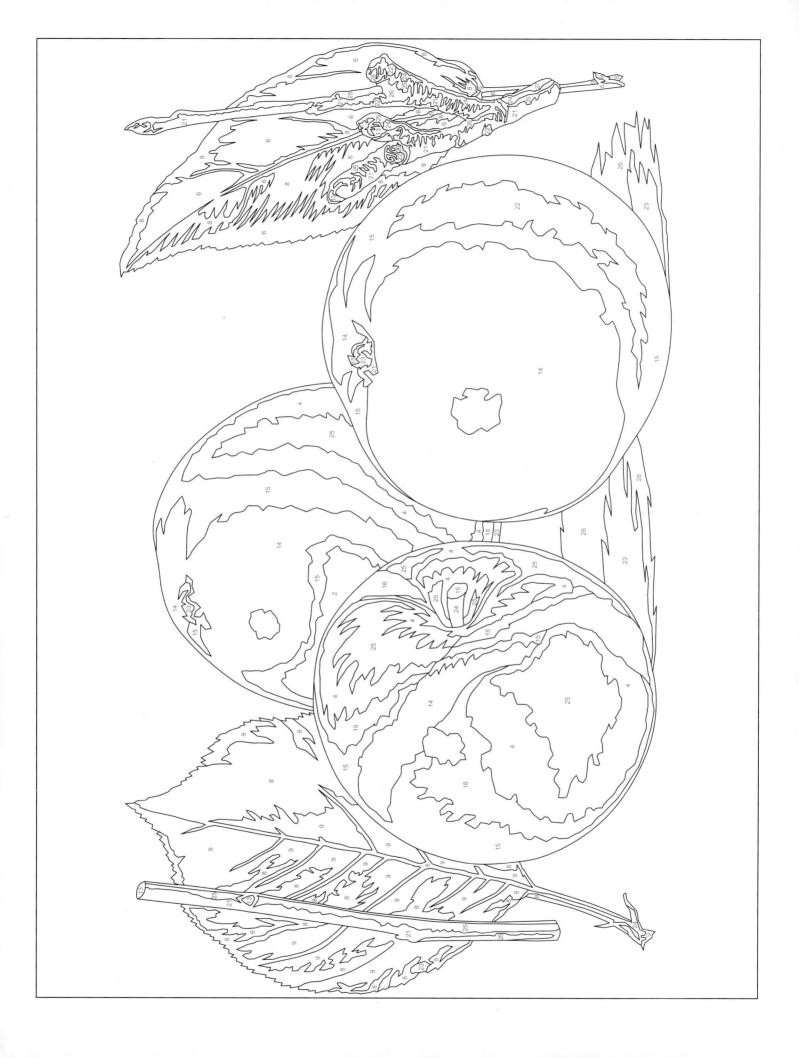

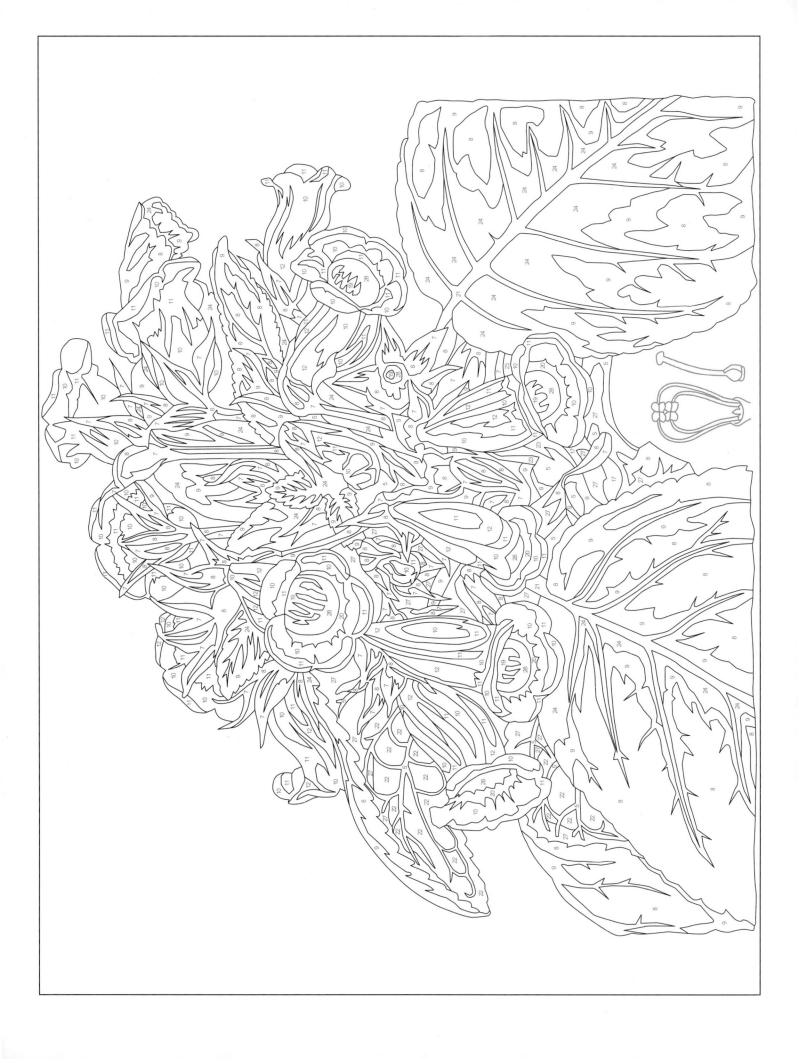

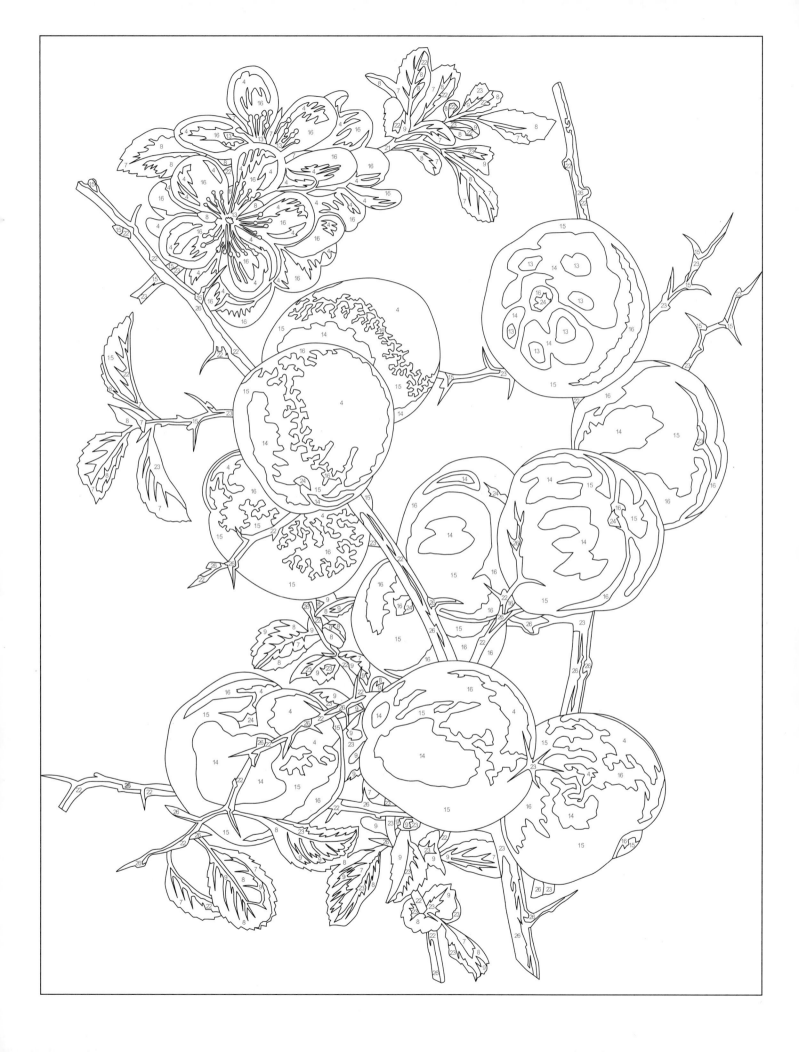

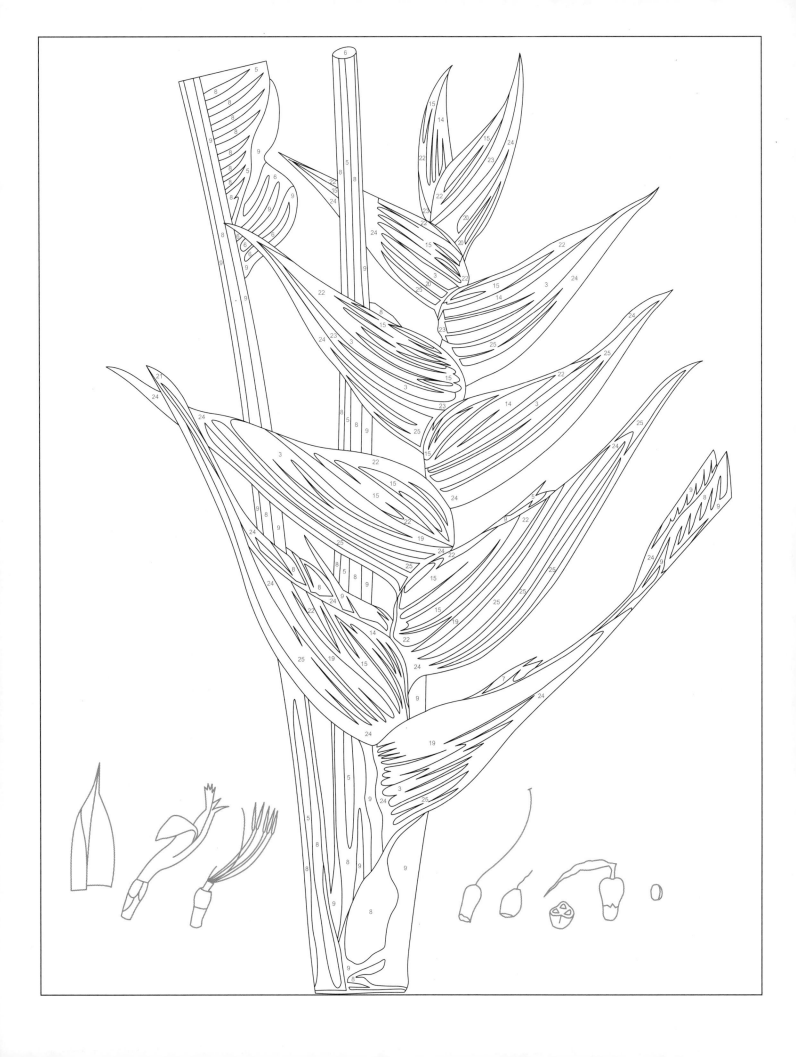

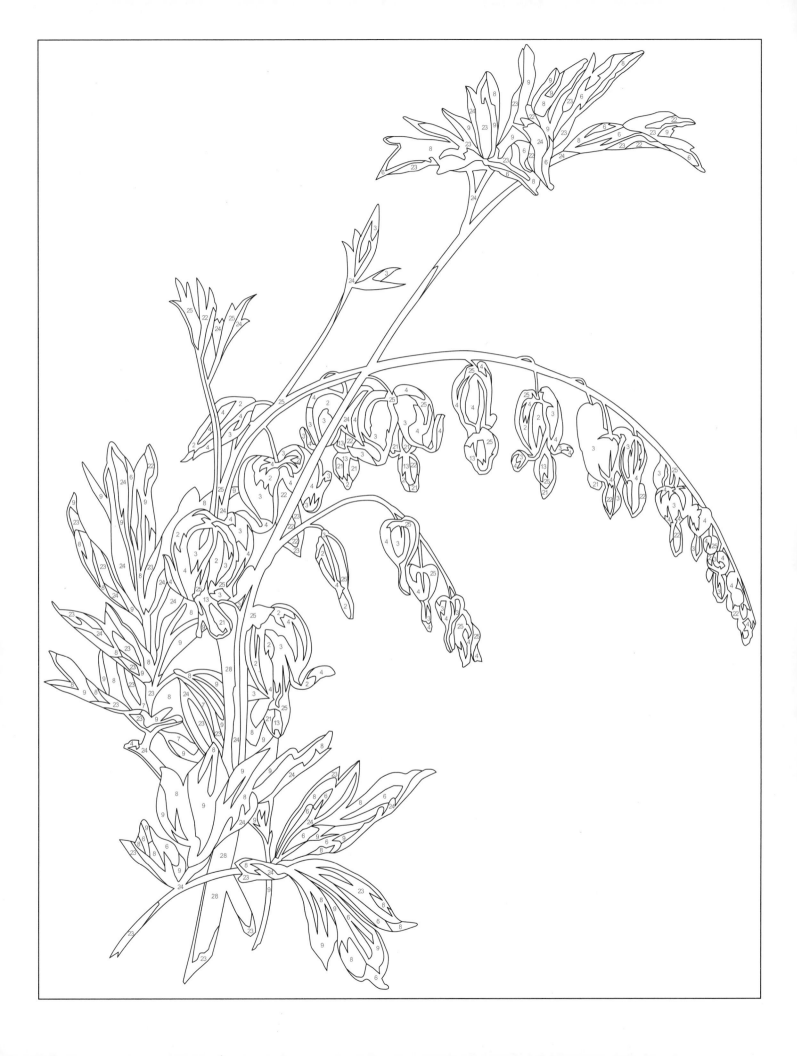

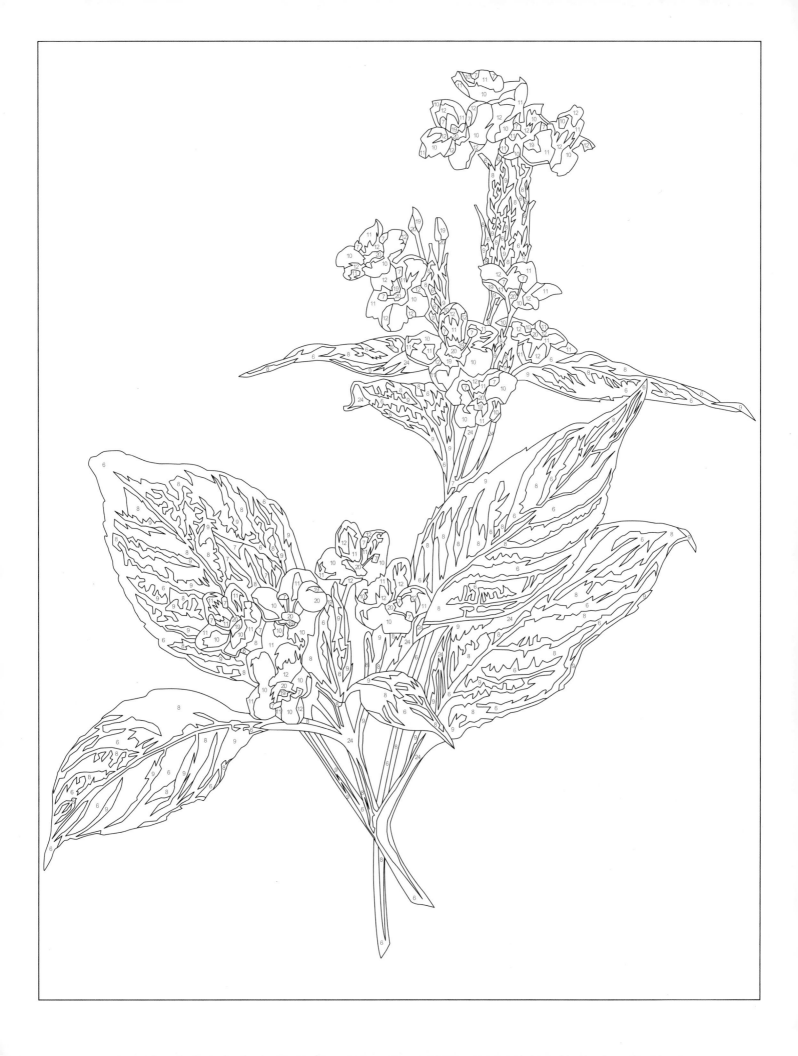

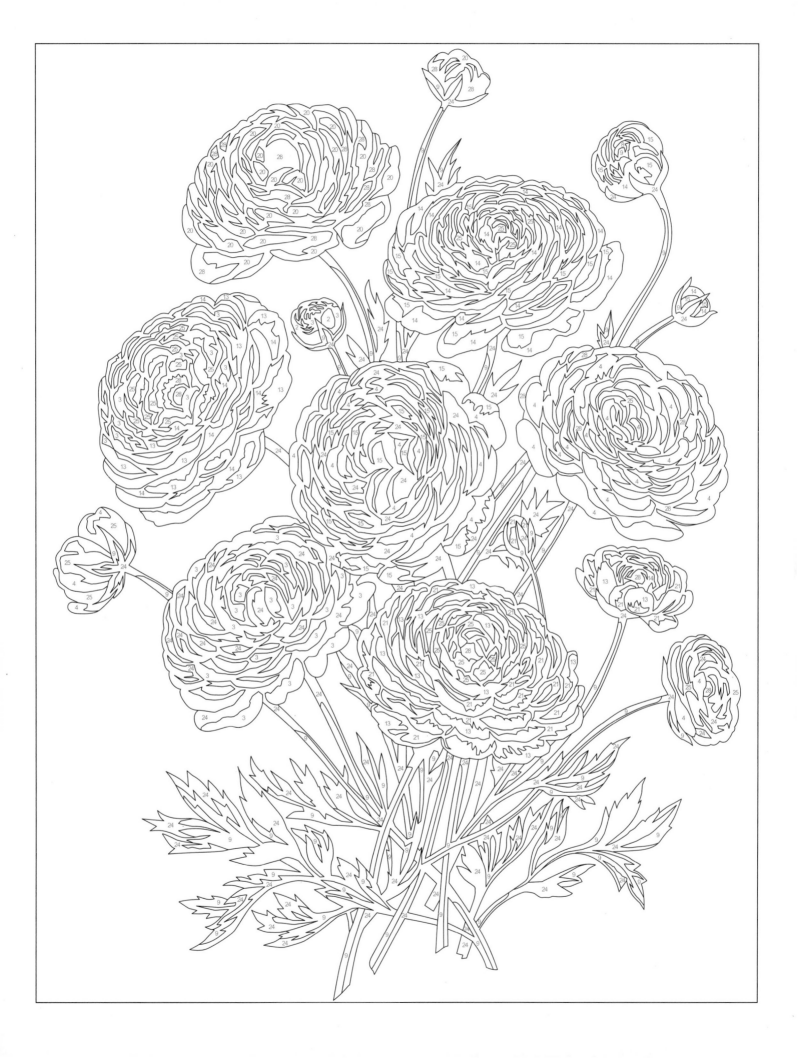

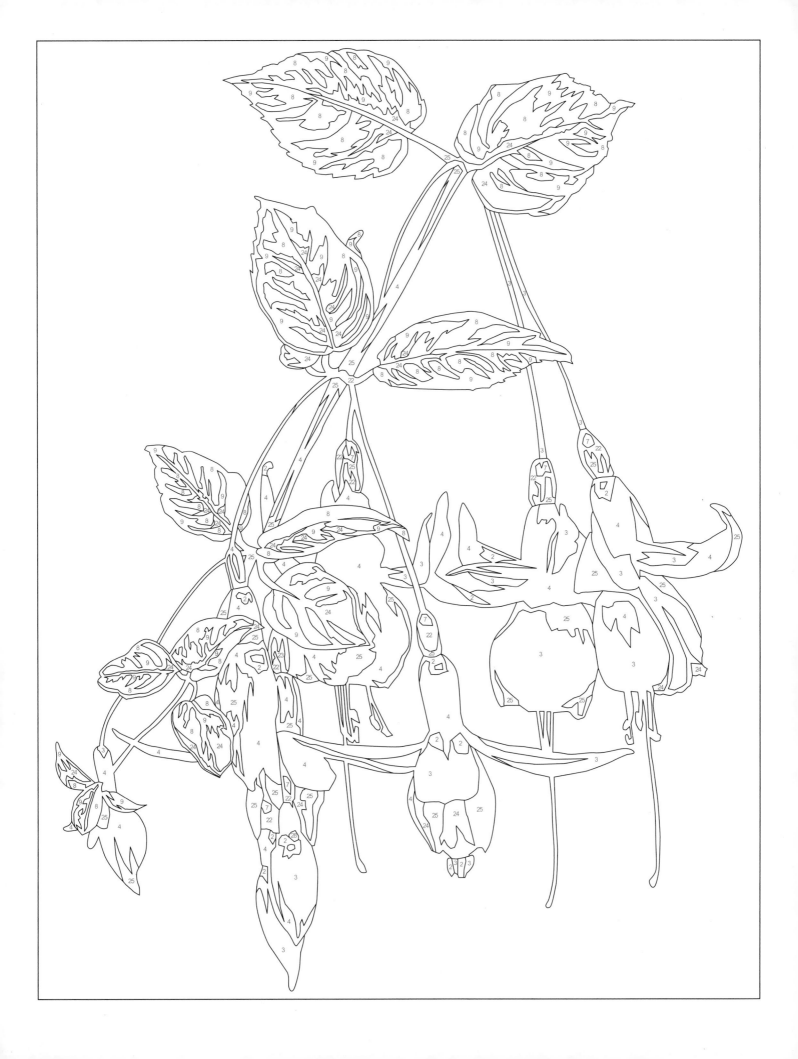

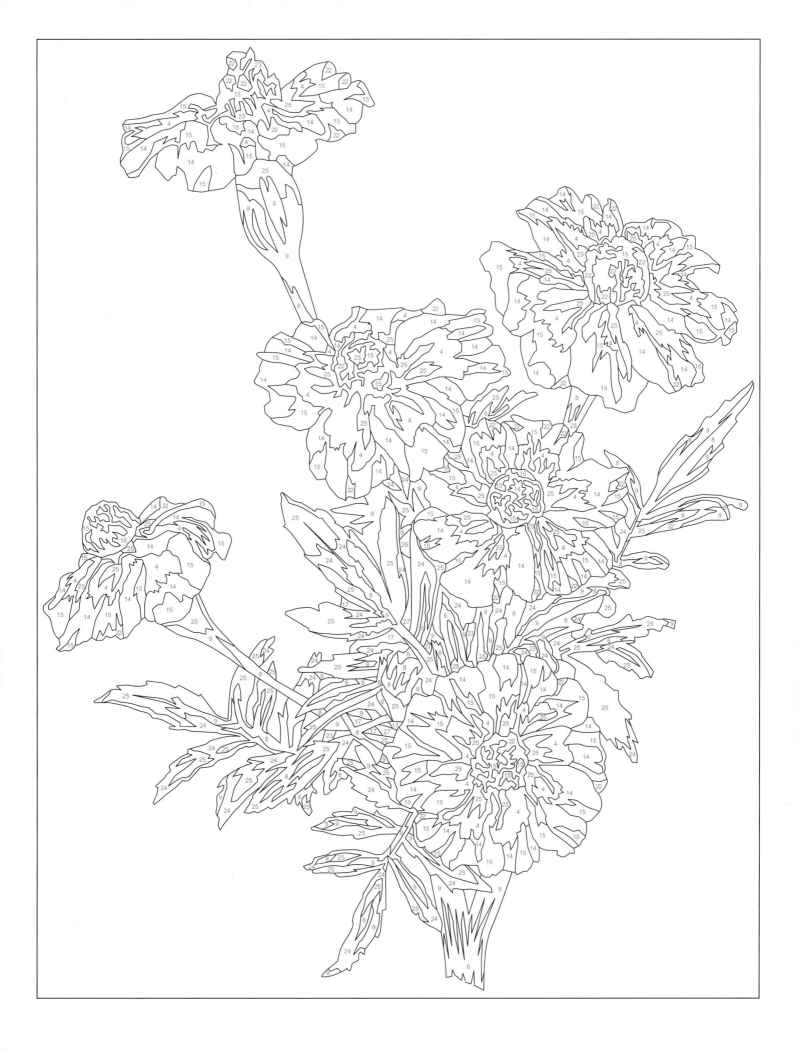

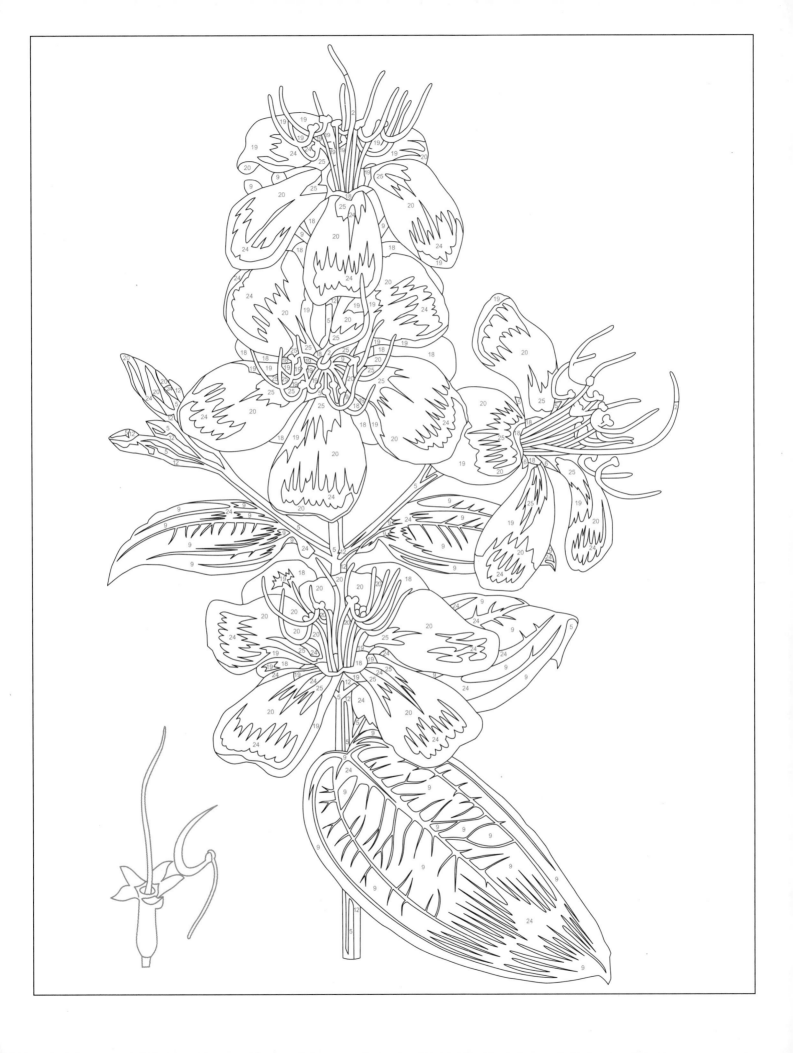

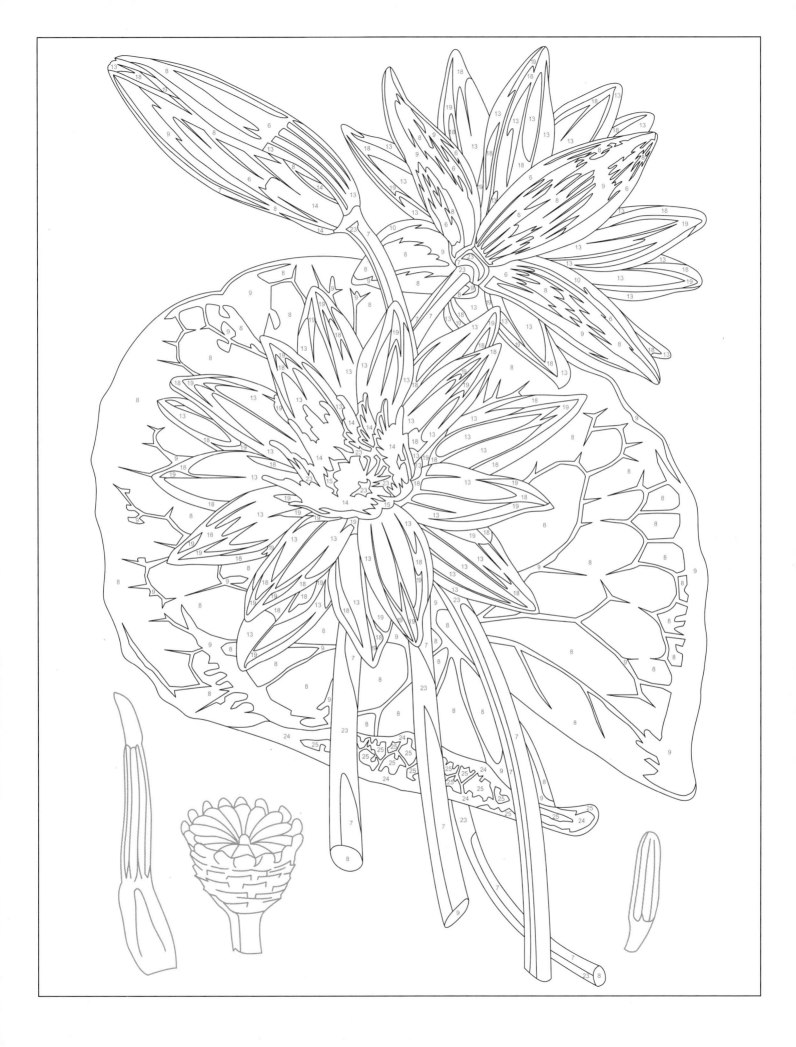

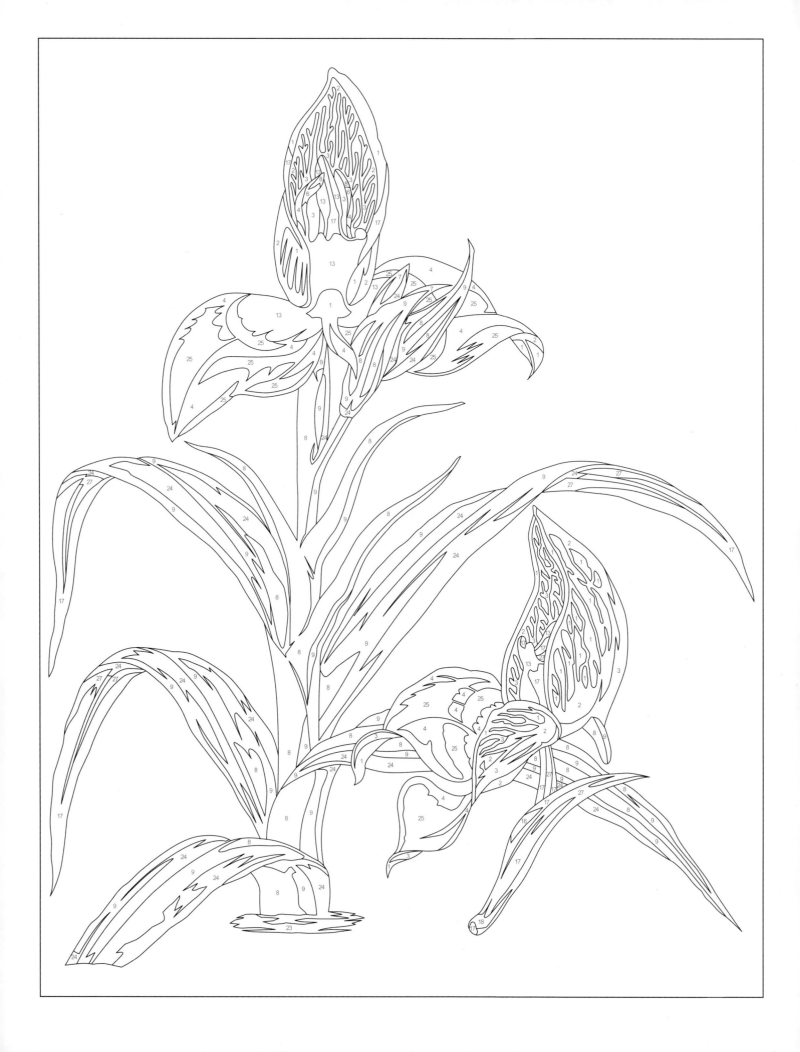

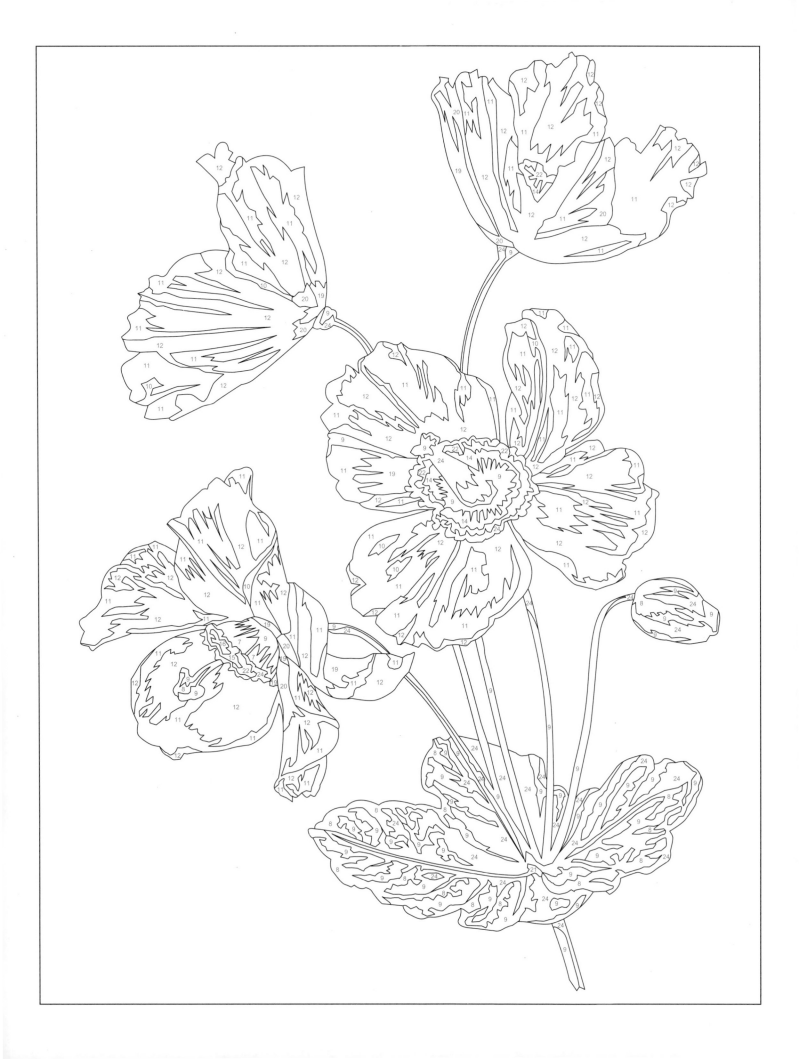

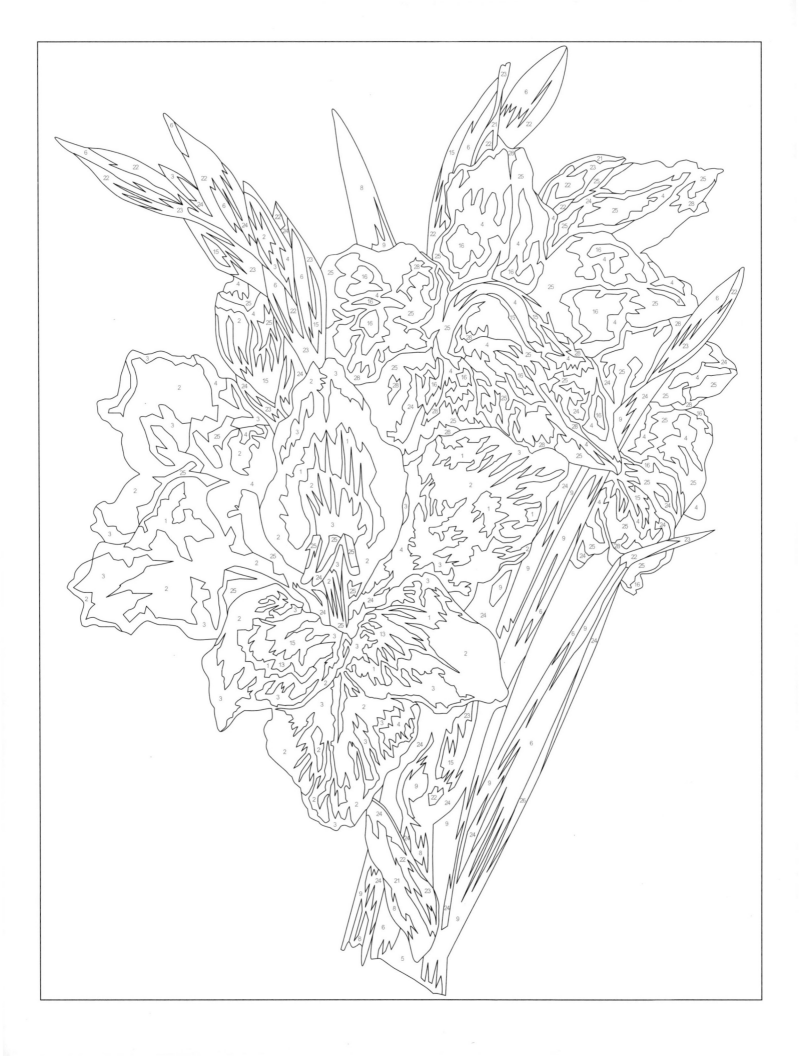

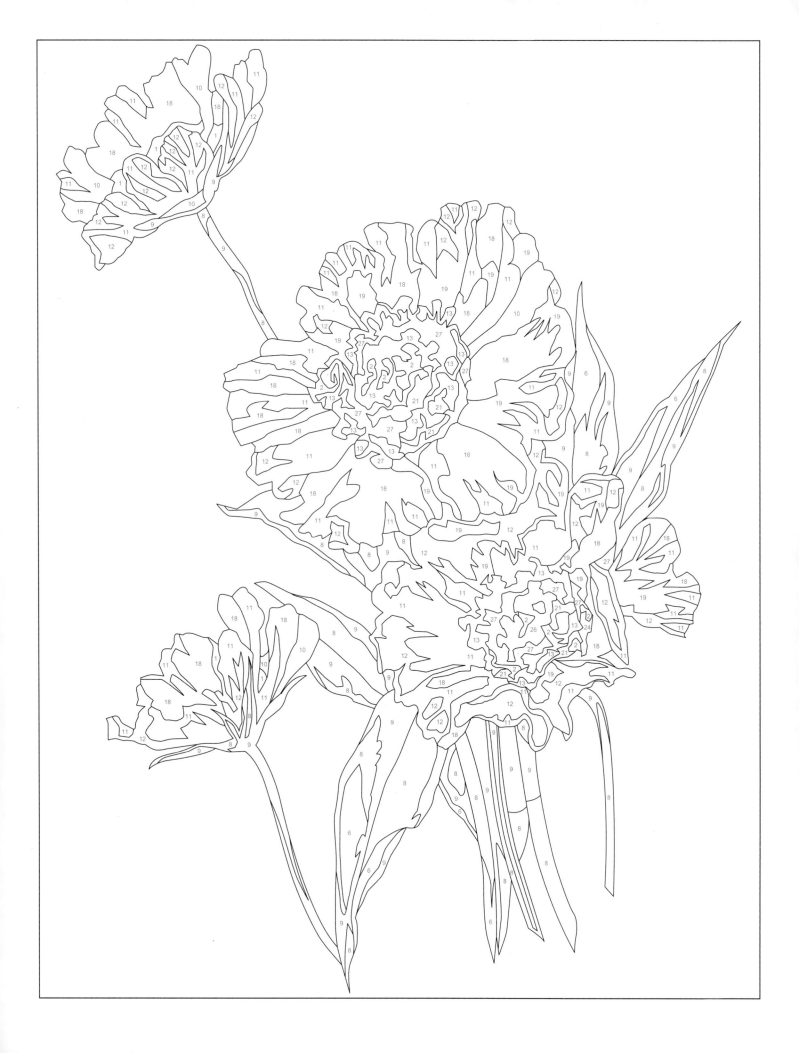

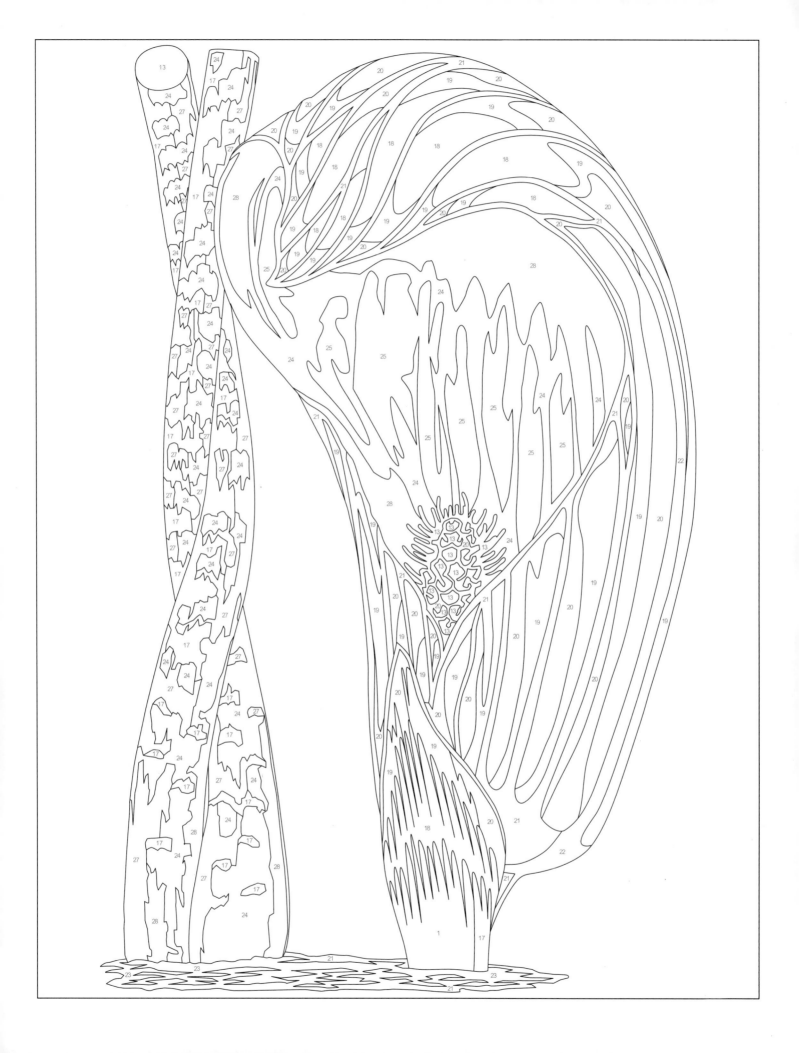

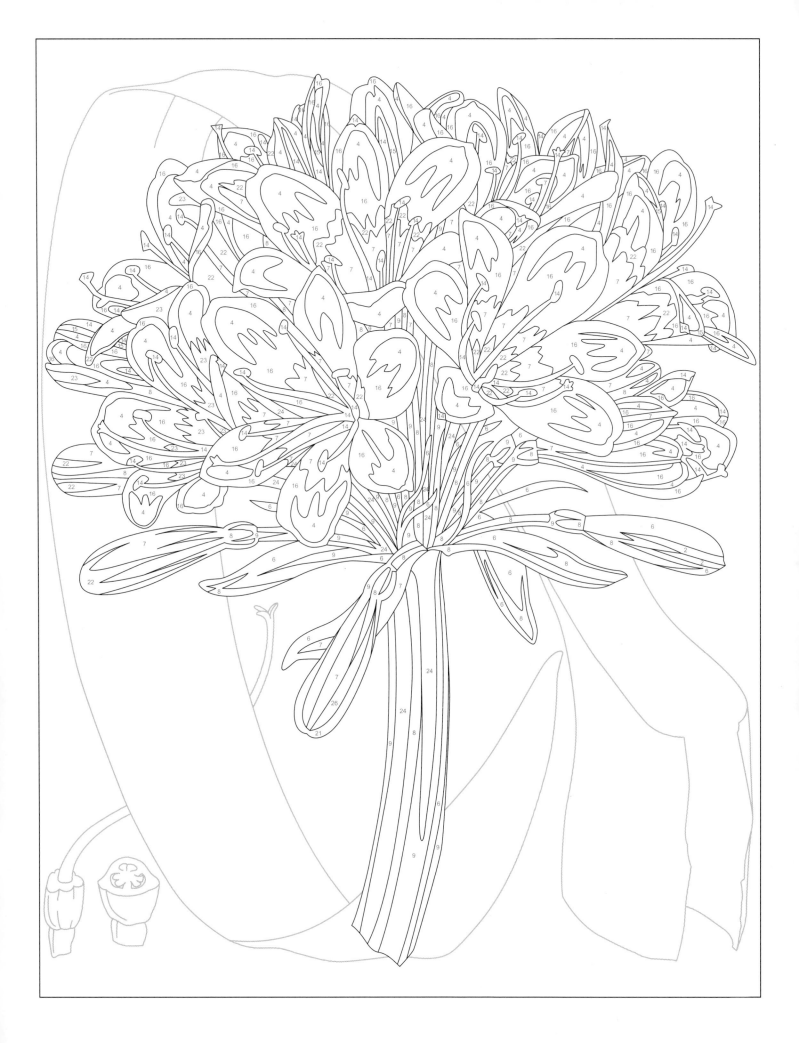

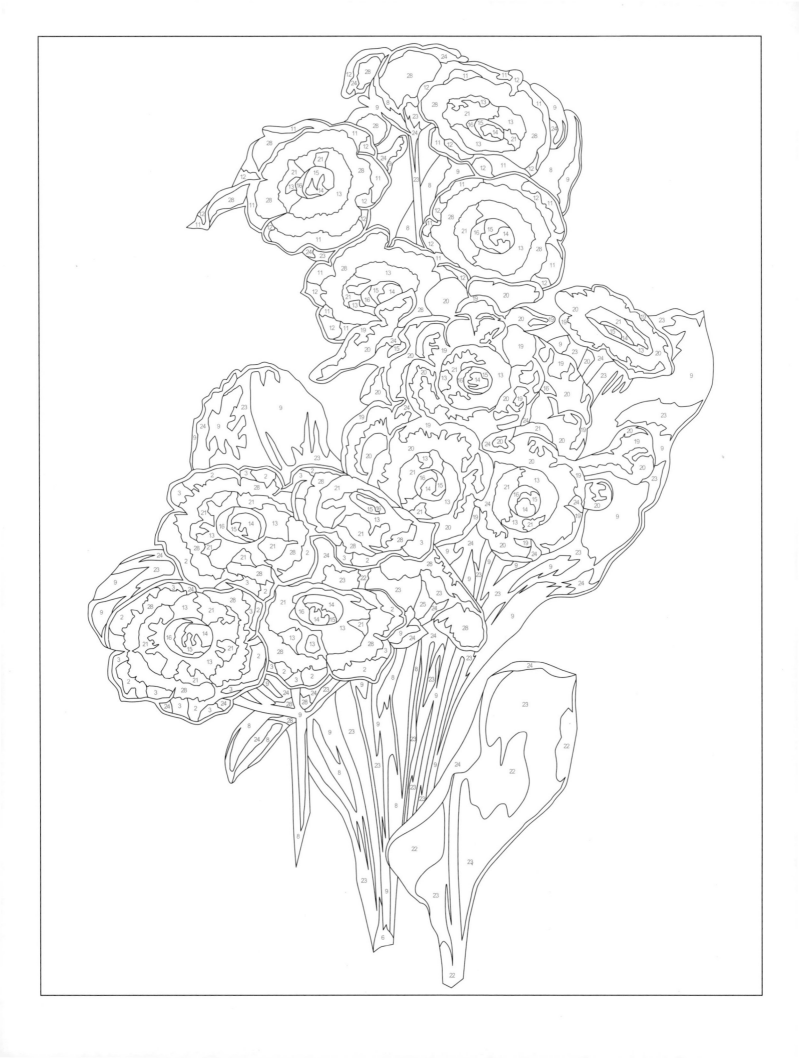

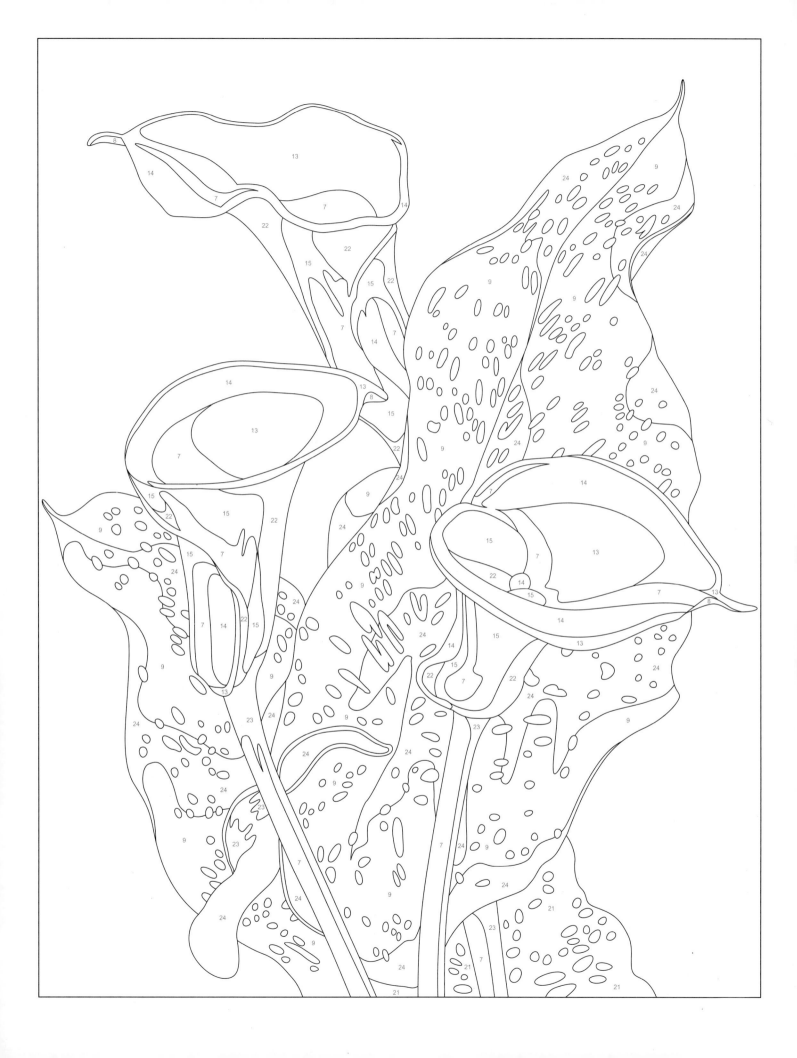

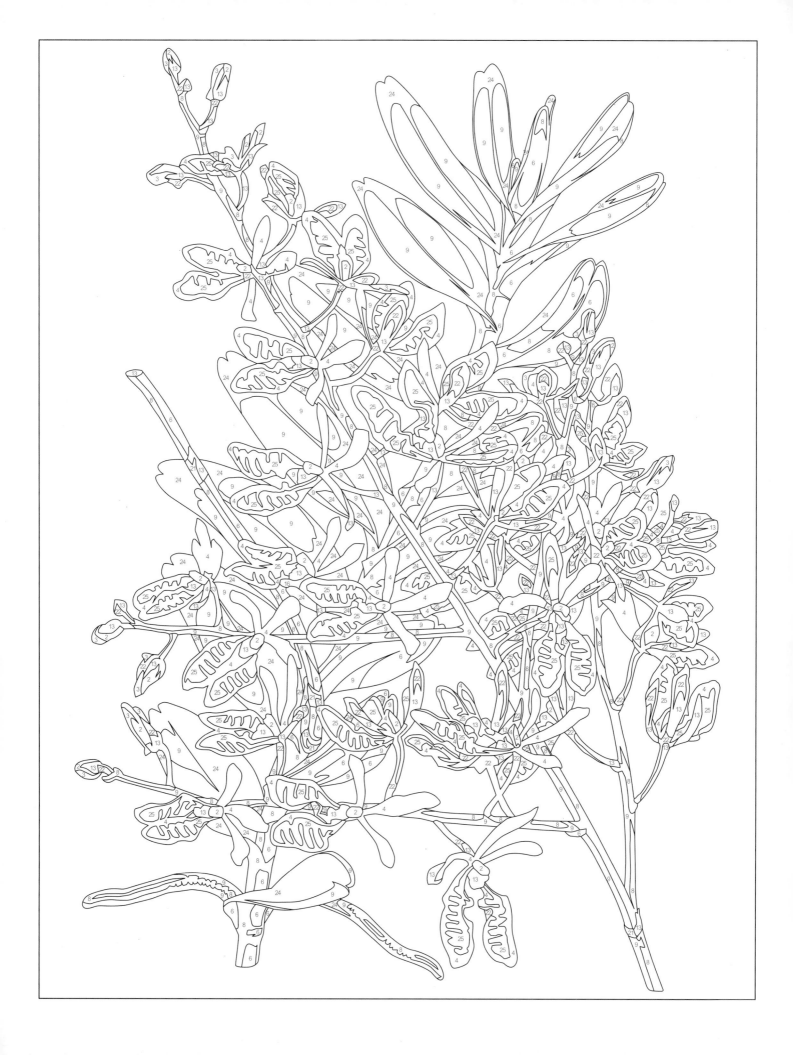

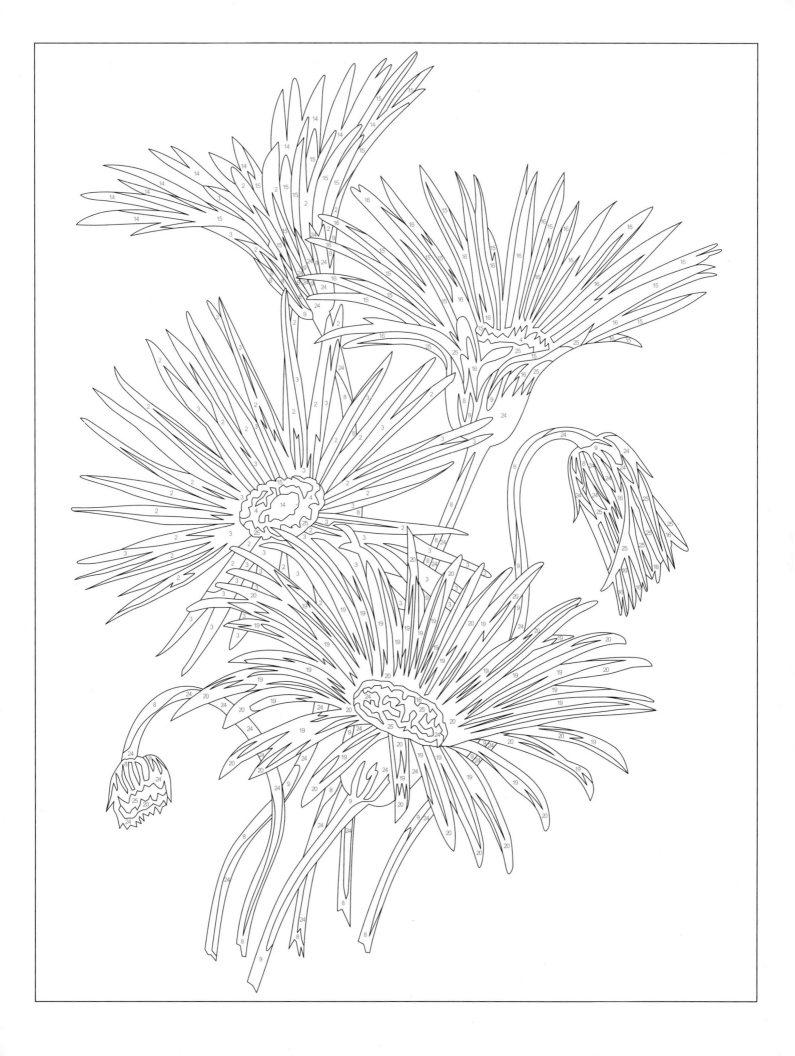

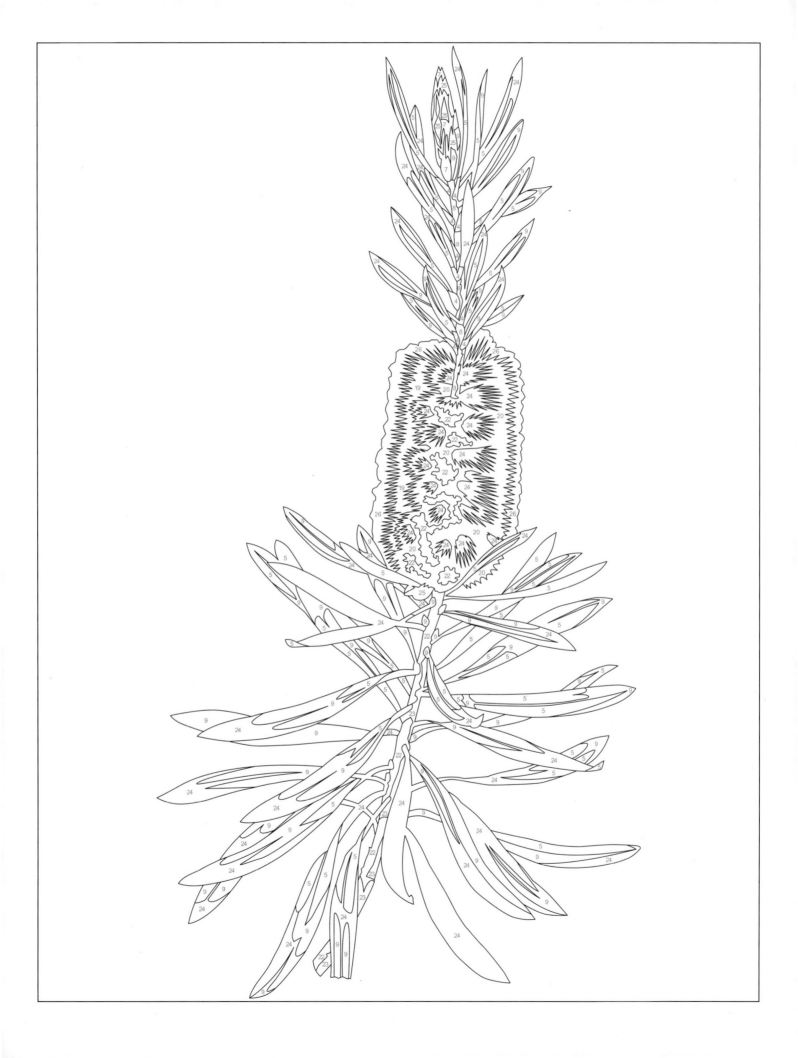

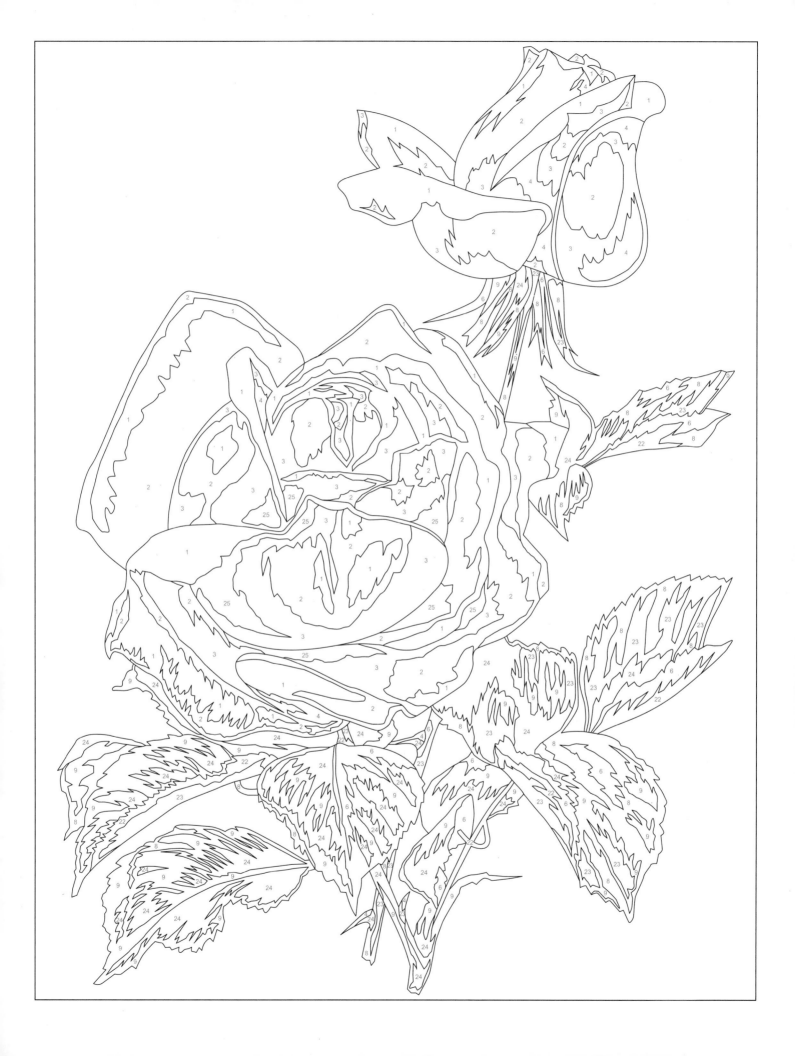

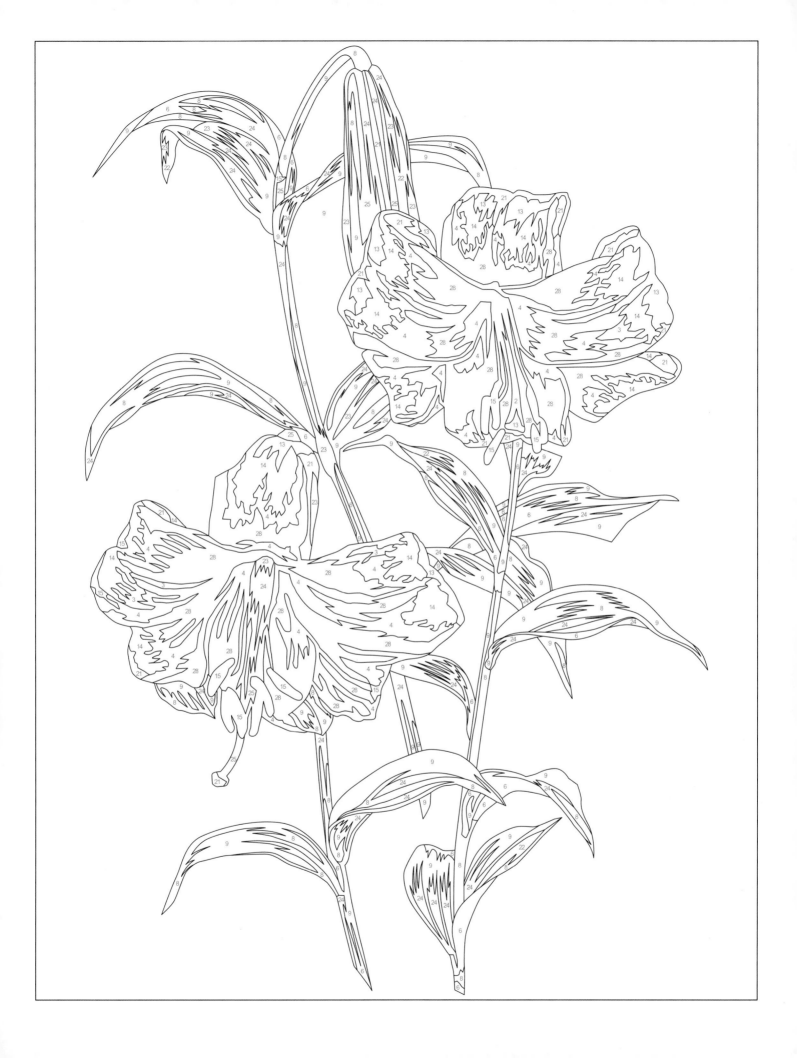

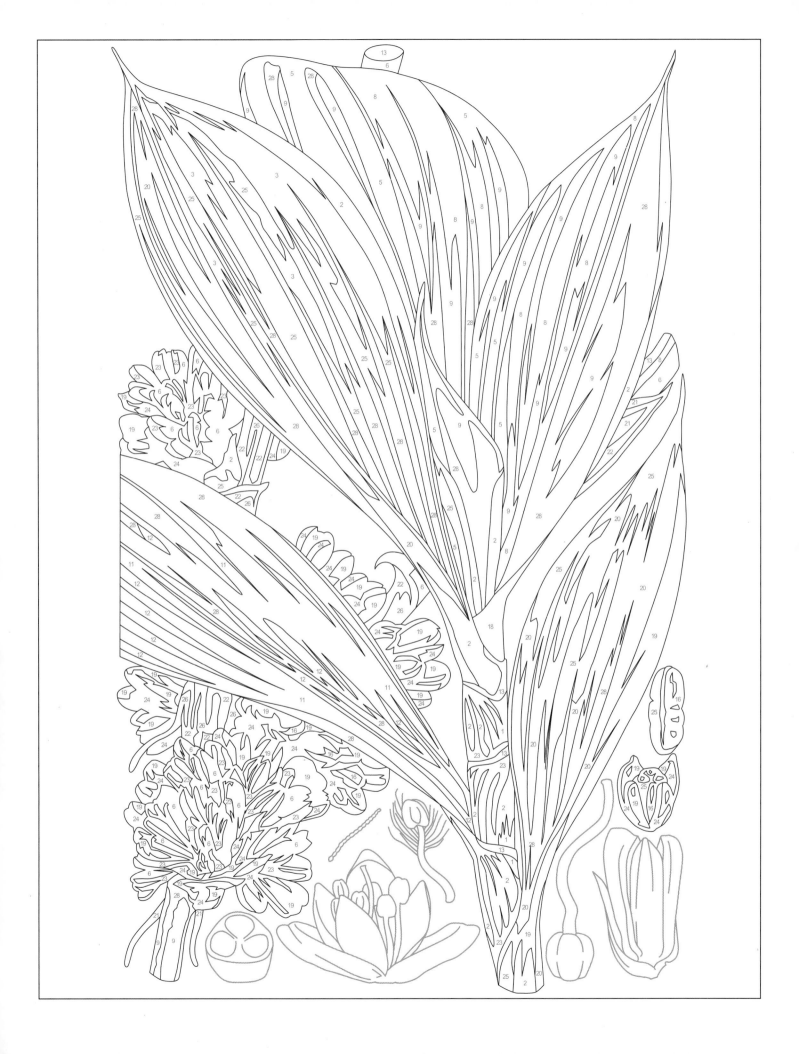

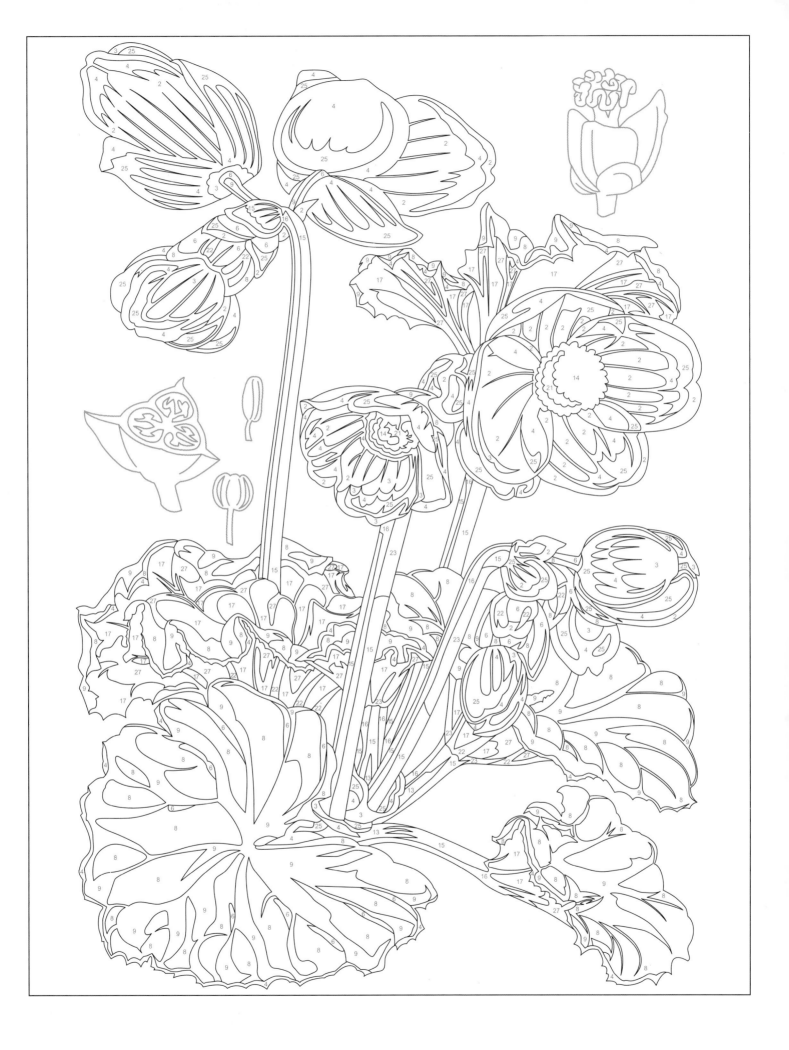

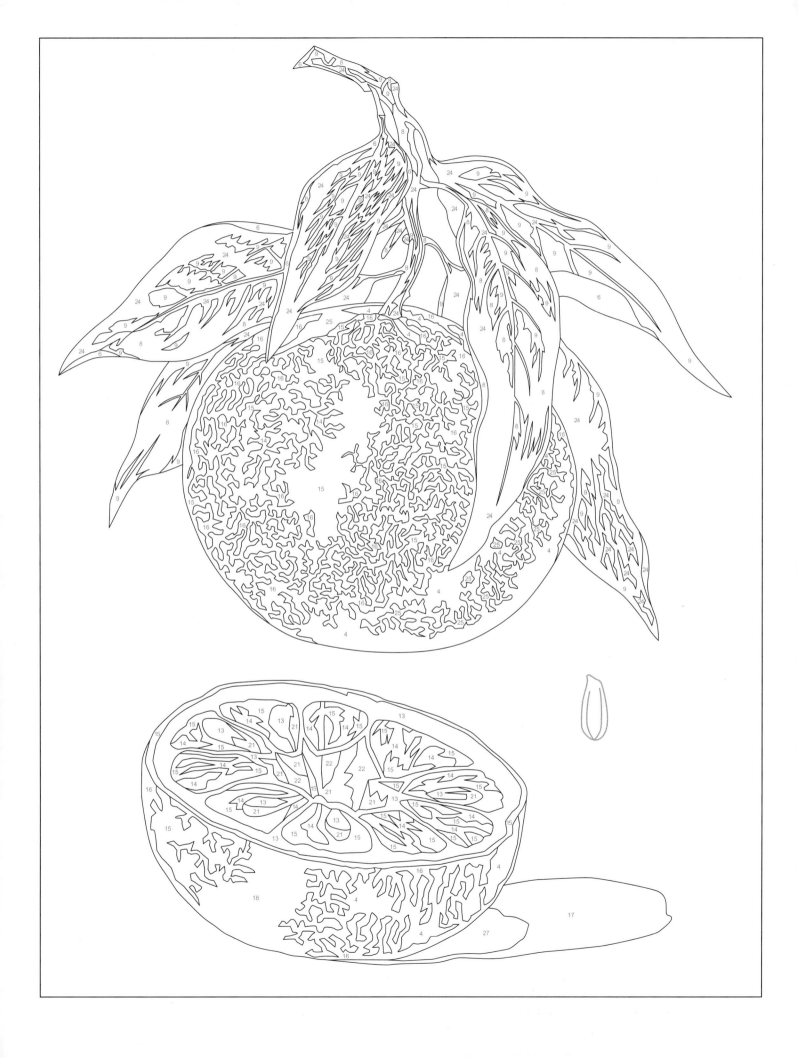

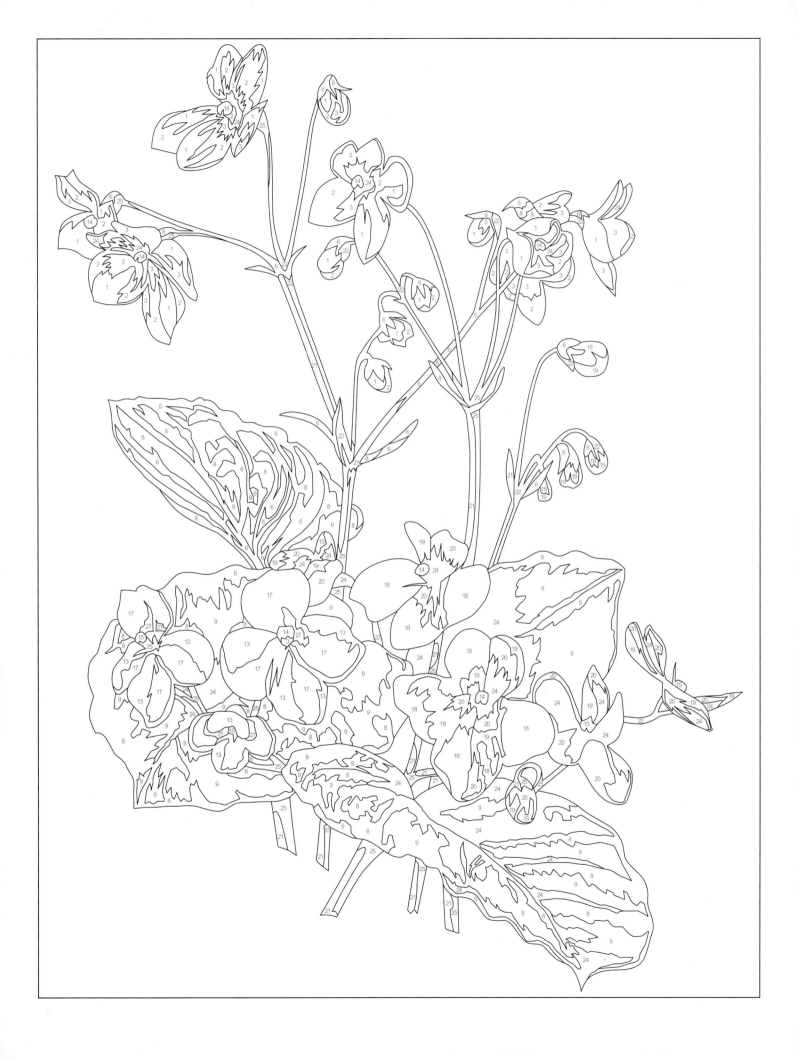

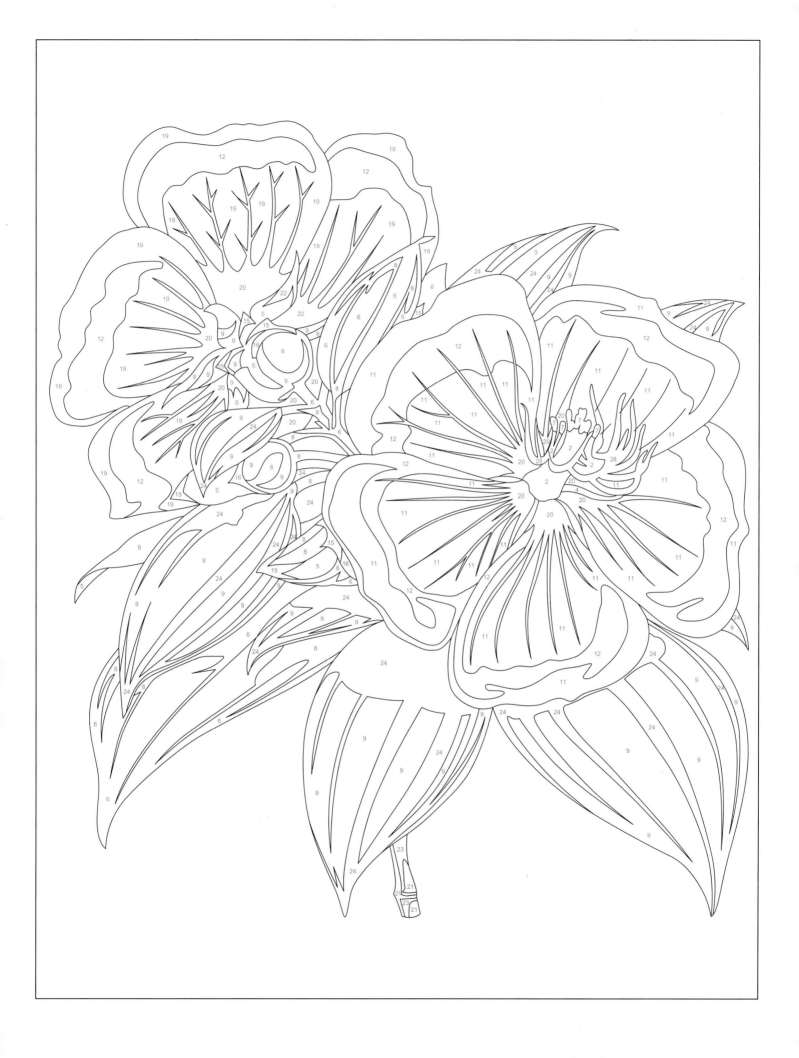

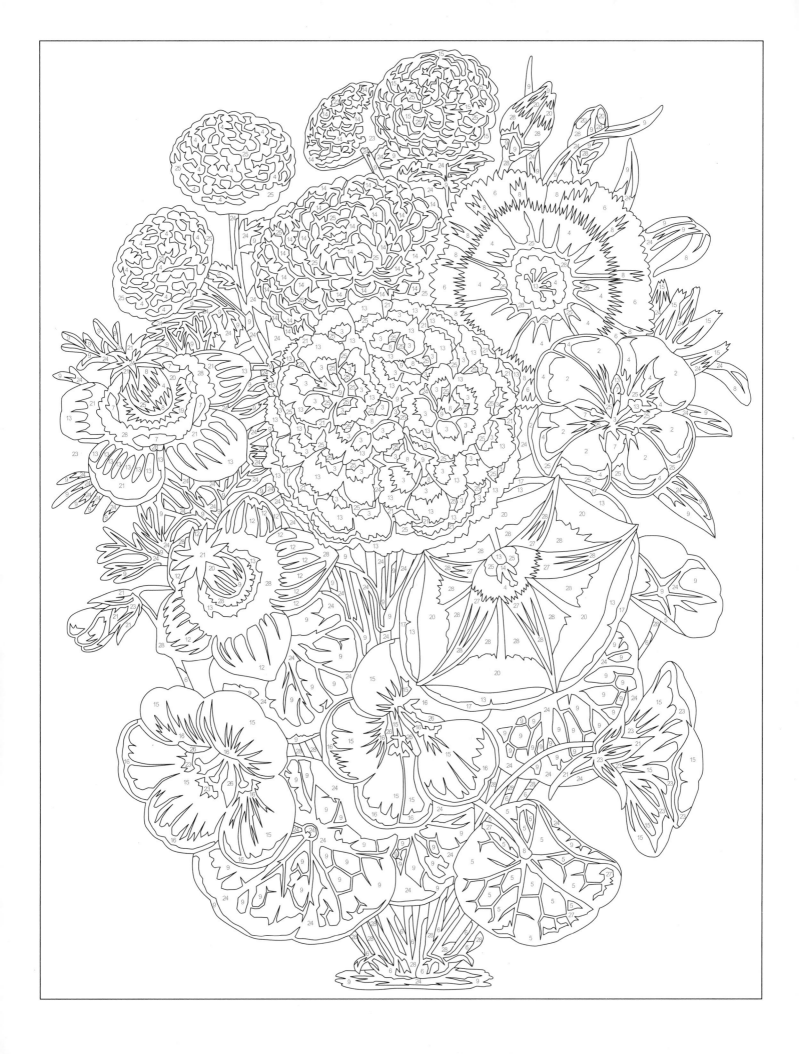

List of Plants

Note on plant names: The names provided here are the names by which the plants would have been labelled at the time of their publication. Subsequent possible reclassification has not been applied.

Page 7 – *Anthurium atrosanguineum*

Page 9 – *Narcissus* (mixed)

Page 11 – *Eustoma grandiflorum*

Page 13 – *Dahlia* (mixed)

Page 15 – *Aquilegia* (mixed)

Page 17 – *Cyclamen* (mixed)

Page 19 – *Iris monnieri*

Page 21 – *Cestrum elegans*

Page 23 – *Lupinus polyphyllus*

Page 25 – *Arisaema speciosum*

Page 27 – *Plumeria rubra.*

Page 29 – *Tulipa greigii*

Page 31 – *Nepenthes veitchii*

Page 33 – *Disocactus × mallisonii*

Page 35 – *Cattleya × elegans*

Page 37 – *Malus*

Page 39 – *Gloxinia speciosa*

Page 41 – *Chaenomeles japonica*

Page 43 – *Heliconia psittacorum*

Page 45 – *Dicentra spectabilis*

Page 47 – *Eranthemum pulchellum*

Page 49 – *Ranunculus asiaticus* (mixed)

Page 51 – *Fuchsia*

Page 53 – *Tagetes*

Page 55 – *Rhexia viminea*

Page 57 – *Nymphaea elegans*

Page 59 – *Disa uniflora*

Page 61 – *Meconopsis baileyi*

Page 63 – *Gladiolus* (mixed)

Page 65 – *Scabiosa caucasica*

Page 67 – *Dracontium polyphyllum*

Page 69 – *Clivia miniata*

Page 71 – *Primula auricula L.*

Page 73 – *Arum*

Page 75 – *Renanthera coccinea*

Page 77 – *Gerbera* (mixed)

Page 79 – *Callistemon speciosus*

Page 81 – *Rosa Jonkheer*

Page 83 – *Lilium nepalense*

Page 85 – *Amischotolype hispida*

Page 87 – *Begonia clarkei*

Page 89 – *Citrus clementina*

Page 91 – *Saintpaulia ionantha* (mixed)

Page 93 – *Pleroma macranthum*

Page 95 – *Dianthus* (mixed)